Calum Creasey

BUILD A CAMPERVAN

The definitive guide

Lannoo

CONTENTS

ONE - INTRODUCTION

Always be learning	**26 - 29**
Where are you on the spectrum of builder?	**30 - 33**
Where are you in the campervan design process?	**34 - 37**
Hierarchy of needs	**42 - 59**
Who?	44 - 53
Where?	54 - 57
When?	58 - 59
How you spend your time	**60 - 81**
Sleep	60 - 65
Rest	66 - 67
Eat	68 - 71
Wash	72 - 75
Play	76 - 81
Selfbuild case study 01 - Sam & Meg	**82 - 87**

TWO - PREPARATION

Budget	**92 - 95**
Example budgets	95
Project planning	**96 - 97**
Vehicle weight	**98 - 103**
Safety	98
Licensing	99
Determining your finished campervan weight	100 - 102
Materials	**104 - 109**
Toolset and mindset	**110 - 113**
Essential campervan tools	114 - 127
Consumables	128 - 131
Workspace	**132 - 137**
Selfbuild case study 02 - Andrew & Emma	**138 - 143**

THREE - THE BUILD PROCESS

Vehicle preparation	**147 - 148**
First fix	**149 - 173**
Installing windows and vents	156 - 167
Ventilation, lining and insulation	168 - 173
Habitation systems	**174 - 203**
Electrical power	178 - 193
Batteries and chargers	194 - 197
Solar energy	198 - 199
LPG gas	200 - 201
Diesel	202 - 203
Selfbuild case study 03 - Tom	**204 - 207**
Water and plumbing	**208 - 219**
Tanks	210 - 211
Submersible pump system	212 - 213
Pressure-activated pump system	214 - 216
Pipework and connections	216 - 218
Filling and filtration	218 - 219
Cleaning and maintenance	219
Furniture	**220 - 241**
Weight	224
Fit	226 - 227
Materials	228 - 231
Carpentry and joinery	232 - 237
Hardware	237 - 238
Finishing	238 - 241
Final touches and trial runs	**242 - 245**
Selfbuild case study 04 - 'Körmi' Kerstin Bürk	**246 - 251**

ABOUT THE AUTHOR

My story is far from unique. In fact, in the context of campervans, it is similar to many. I come from a large family and have three older sisters. Our family holidays were spent in a big Volkswagen LT coach-built campervan, heading south each year to the beaches and waves of Cornwall and Devon. The wagon was adapted, modified and upgraded by my parents. They added beds and changed the layout to better suit us and our small dog. They replaced the upholstery and curtains when the fabric became old, and rebuilt the engine when it blew up. I watched all of this, in awe of how a small space that felt so much like home could take us to new places on four wheels. The driving was as fun as the destination, with a large table surrounded by a U-shaped seating area at the back. On the odd occasion that my sisters were not frustrated by my antics, I was allowed to sit and play cards there. When I felt too cool to hang around with them, or was shunned for being annoying, I would walk up to the front and sit behind the cab area to watch my dad drive and my mum read the maps.

When the time came to get my own van, I bought a Nissan Vanette from eBay for the modest sum of £700. The intention was to build something of my own. To pour into it that rebellious teenage spirit and take my then girlfriend – now wife, Lauren – on the same adventures that I had enjoyed. And to create some of our own. I knew in the back of my mind I was re-enacting something from before. I built a simple interior in

the back. With a kitchen/storage unit and pull-out bed. That van took us all over the UK and on our first campervan trip to Europe. Surfboard, gas stove, blankets. All carefully packed.

Once that van was sold, I upgraded to a Volkswagen T4. The build process was repeated and refined. The van once again became our rolling home. Years later, after trying many other paths, I decided to start a company to build bespoke campervans for other people. Now I own and run a workshop in Cornwall. The campervans are built for all kinds of people. In various shapes and sizes. Each unique but all with the same goal: to take people on adventures in relative comfort. You could say I have become somewhat of a campervan expert. I design, buy, build, drive, sell, photograph, write and dream about them.

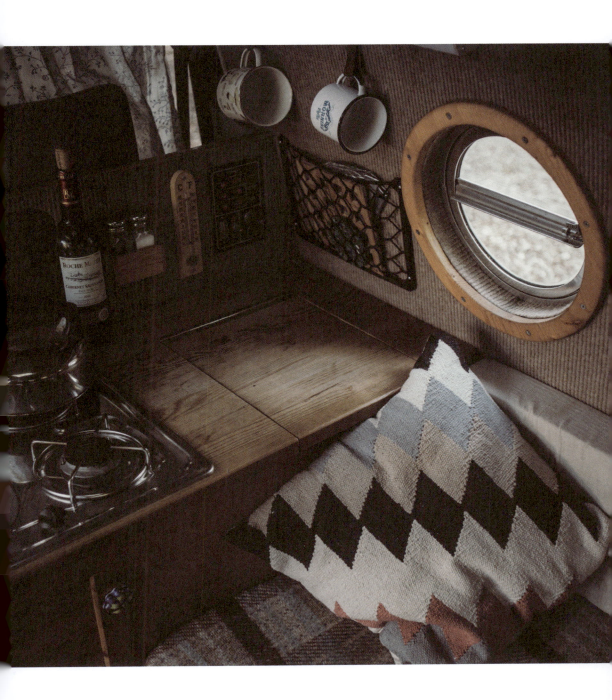

Part One

INTRODUCTION

I have spent the past five years building campervans professionally. Before this, I built them for myself and my now wife, Lauren, to travel around Europe in the most affordable way possible. This story has played out in a similar fashion for people all over the world. Those who build their own campervans often start with a modest design and refine it until their skills have developed and their campervan meets as many of their needs as possible.

Some, like me, go on to build many campervans, usually bigger and more ambitious. Yet still try to retain that magic they discovered with that first build. Some, also like me, go on to open their own businesses that build campervans for other people, using the skills they have developed to create bespoke vehicles for those who do not have the time, space or resources to build their own.

These vehicles have the capacity to move you physically, mentally and spiritually. This is a bold claim, but bear with me a moment. I have written extensively (elsewhere) about the 'Why': the dreams that fuel our desire for a campervan are varied, yet when discussed, the same themes reoccur time and time again. I have learned a great deal from every campervan I have built (30+ to date). Each has been unique. Built around the individual. The

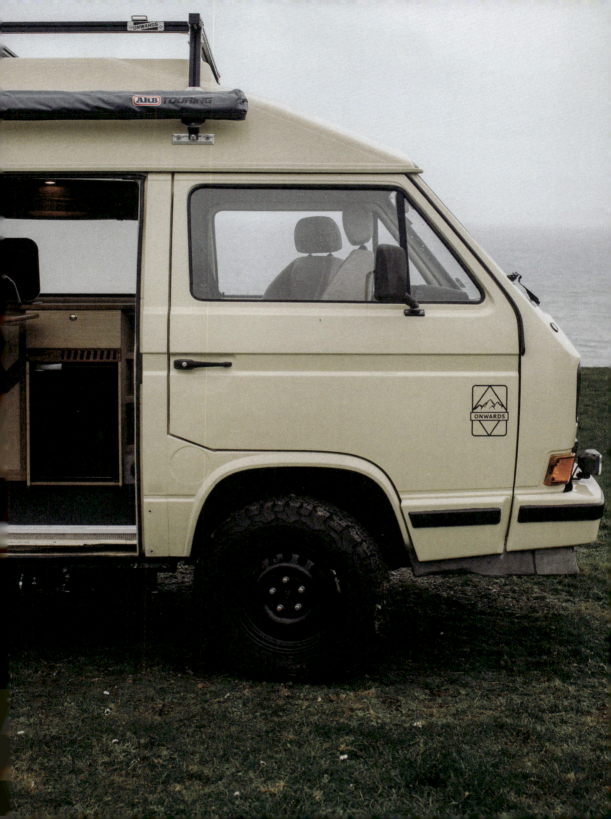

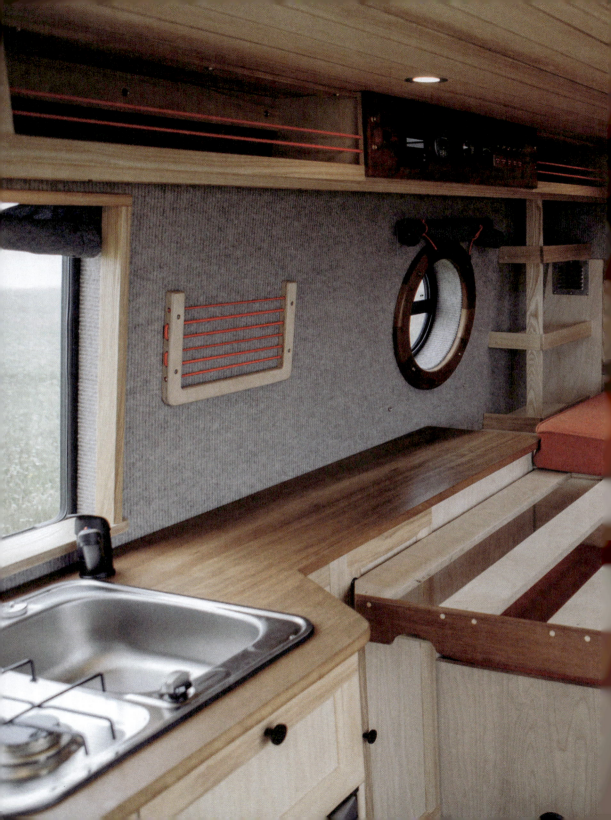

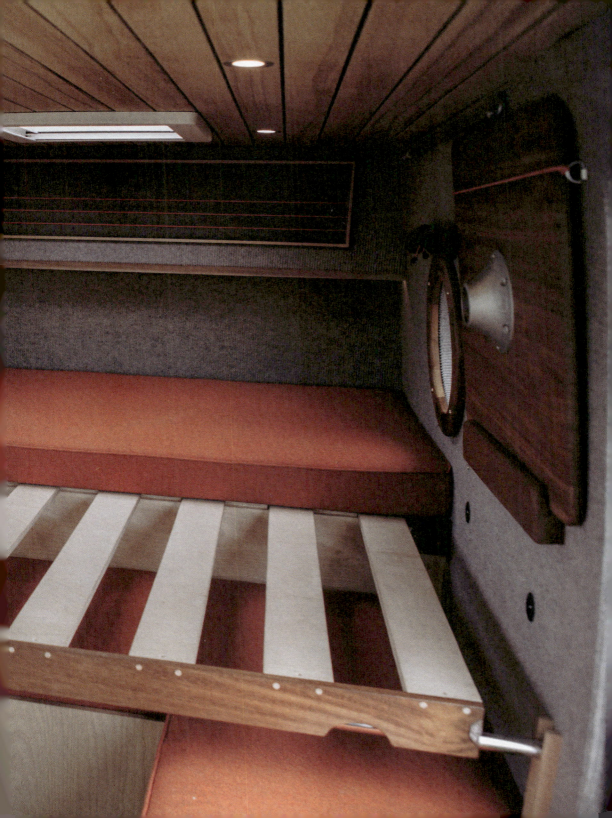

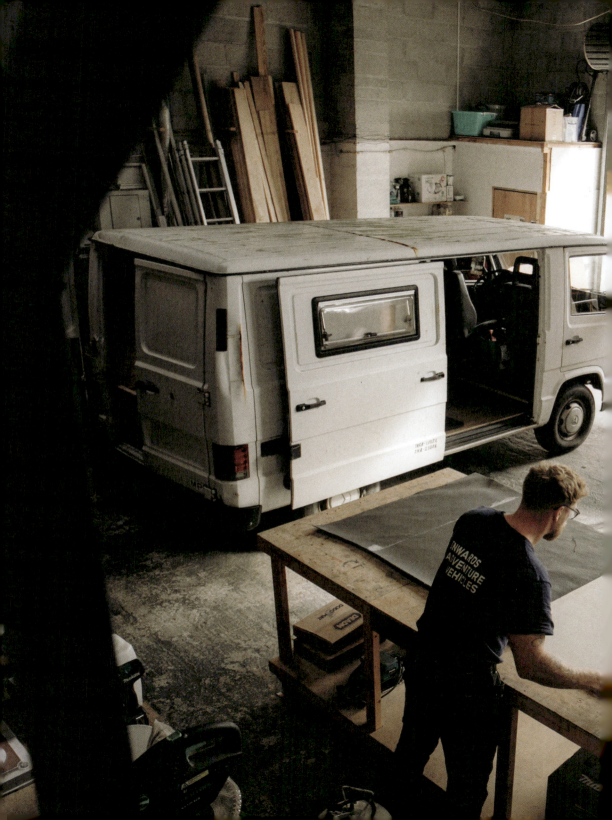

Goldilocks effect in action, where the arrangement of furniture or choice of materials are informed by unique tastes. I have designed bespoke campervans that feel 'just right' and others that have needed adaptation and further refinement. What works in theory sometimes doesn't in practice. But often the feeling of having built your campervan, and the ability to learn from the never-ending feedback loop, can be incredibly satisfying.

You may be wondering where you fit into this? You may have considered building a campervan yourself or paying a professional to build one for you. My hope is that this book will be the spark of inspiration you need to embark on your own self-build. This sounds counterintuitive to my business model, and indeed it is. But that's fine by me.

Some finished work you will want to admire, others you may want to throw in the trash and start again.

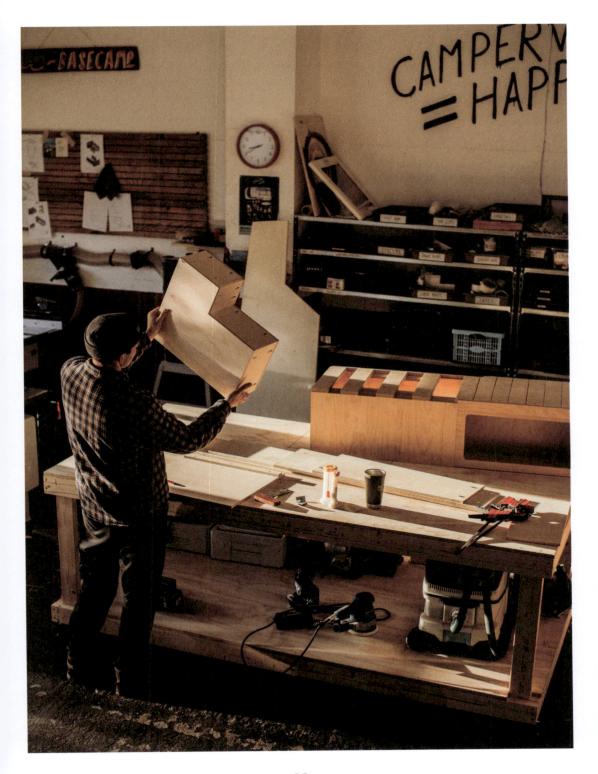

Whether you have access to a professional workshop and machinery, or a driveway and what you can beg, borrow or steal (not advised) in terms of materials and tools, the process is the same. You may be an accomplished carpenter, or a complete novice. In this book, I lay out the process that we take with those who commission me to build them a campervan. Before we touch any tools, we will start with your mindset, what challenges to expect and how to prepare. Setting your project on the right path early will make all the difference.

ALWAYS BE LEARNING

'What works becomes invisible.'

Ever noticed how you only become distinctly aware of your car when it breaks down? The reason for this is that when unexpected events happen, we have to quickly update our working model of the world. You may already have a vision of your campervan in your mind, or one will develop as you meticulously plan the project. But what is guaranteed is that the process will not go exactly as planned. I have days in my workshop when an error in measurement will lead to a piece of timber being cut too short. CAD designs can be incorrect, and our CNC (computer numerically controlled) router machine ruins a full sheet of plywood as a result. The key, and I cannot stress this enough, is to always be open to learning from the mistakes that we make. It fosters a positive mindset that slows us down, allowing us enough time to reassess and think through the unforeseen. The age-old adage of 'measure twice, cut once' still rings loud in my ears, and should do so in yours too.

Later in the book, you will hear from people who have embarked on their own builds. When discussing their projects, the first question that came to mind was 'What did you learn?' The answers are honest, authentic and valuable. Collective wisdom comes from sharing the knowledge that we glean – not from our successes, but from our mistakes.

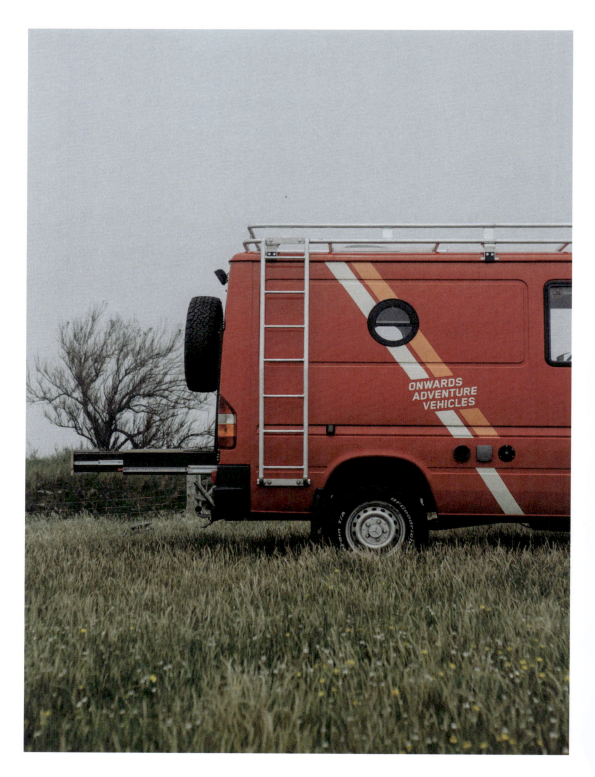

'Every time you turn on a tap, sleep in your bed, or open the window to let in the cool sea breeze, you will not be aware of the time it took you to fit these parts of your campervan. Any piece of successful design can intentionally be judged on how seamlessly it fits into our everyday lifestyles. Built right, your campervan should become invisible.'

WHERE ARE YOU ON THE SPECTRUM OF BUILDER?

Can you make things? Of course you can. Consider us humans and our ability, collectively, to create. To take raw materials, refine them, adapt them, protect them against age and use, and to make our lives more efficient and enjoyable as a result. What a wonderful ability we are all blessed with. It will be beneficial to understand what skills you currently possess, and track how these develop. Here are 3 levels that you may fall into.

1. The Complete Novice

You have never used a handheld tool in your life. Timber and plywood are intimidating. Building flat-pack furniture becomes a mess of parts, nuts, bolts and missing instructions. But you are also a blank canvas! You are eager and motivated to learn!

2. The Intermediate Builder

Maybe you took a woodworking course in school and built something simple. You know your way around basic tools. You approach DIY projects with confidence. Your campervan build will reflect this.

3. The Confident Professional

This is not your first rodeo. You are competent with a wide range of tools, machinery and processes. Your portfolio includes impressive projects, and now you want to add a self-built campervan to that list!

Regardless of your current skill level, you have been a part of this creation process since the day you were born. You were wrapped in a blanket woven by human ingenuity, and you slept on a bed frame made from timber or metal. The plates you ate from and the roof that protected you were all assembled, fixed and built by human hands. Do you see what I'm getting at? This book will challenge your current skills. It will instruct you and inspire you. Developing your ability to build a campervan will in turn allow you to approach any building project with confidence. I have seen firsthand how friends who have built their first campervan go on to renovate properties, develop products and constantly stretch the boundaries of what they were once capable of.

The right attitude will prepare you for the difficult moments during your project.

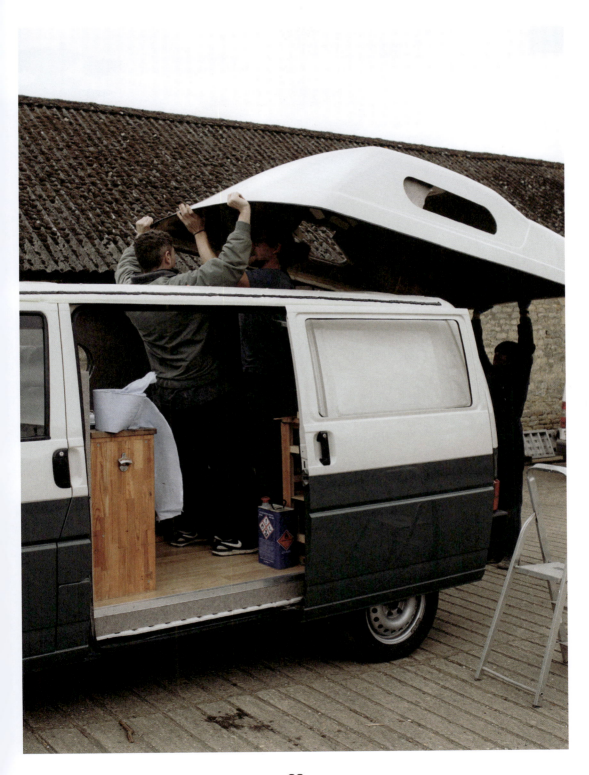

WHERE ARE YOU IN THE CAMPERVAN DESIGN PROCESS?

There are simple campervans and complex campervans. Some are full to the brim with furniture, equipment, tools and everything else you may need for a life on the road. Others are blindingly simple, with next to nothing inside. Some look homemade, like a cosy burrow or hobbit hole. Others stand on the cutting edge, using composite materials and insulation developed by NASA. The intended use informs the design.

When a customer first reaches out to me, be it with a phone call or an email, I ask key questions to quickly gain an understanding of who they are and how they envision their campervan. I can then see how this fits with what is possible. At this point, we encounter the first tussle between dreams and pragmatism. The limited space available, the considerations of a moving vehicle and the budget define what is possible. Working from these three broad constraints, I approach the design process as a 'conical spiral'.

At its start, it is broad and loosely defined. As we move down towards a finished design, it narrows and becomes clearer. The narrowing process reflects various trade-offs and decisions that have been made along the way. This is informed by our initial constraints and a list of 'hierarchy of needs' that we will come

onto shortly. But for now, imagine how a choice such as 'I need a shower cubicle' will inform the weight, budget and available space of the rest of your design.

The final design encompasses layout, material, finishes and habitation systems. It also includes all the kit that will be fixed to the outside of the vehicle. And maybe even mechanical changes such as upgraded suspension, wheels and tyres. The spiral approach is a valuable tool when designing campervans from scratch. In reality, you will bring together your design from various references that might include layouts you have already seen in person or on the internet.

Most customers have either seen one of our builds before or have reference materials that they have gathered from various sources. They also may have owned and/or rented campervans in the past. All of this allows us to skip steps and arrive at the bottom of the spiral quicker.

Tips for considering where you are in the process:

•Gather reference materials from YouTube and other social media. With so many people documenting their own build processes, take some time to view how they have approached the different aspects.

•Try out layouts and use any opportunity to take a look inside a campervan. Even sitting down for a few minutes in a friend's campervan can give you a great insight into the feel and function of the space.

•Rent a campervan: there is no better way to see if a design will work for you than by taking a trip in a campervan.

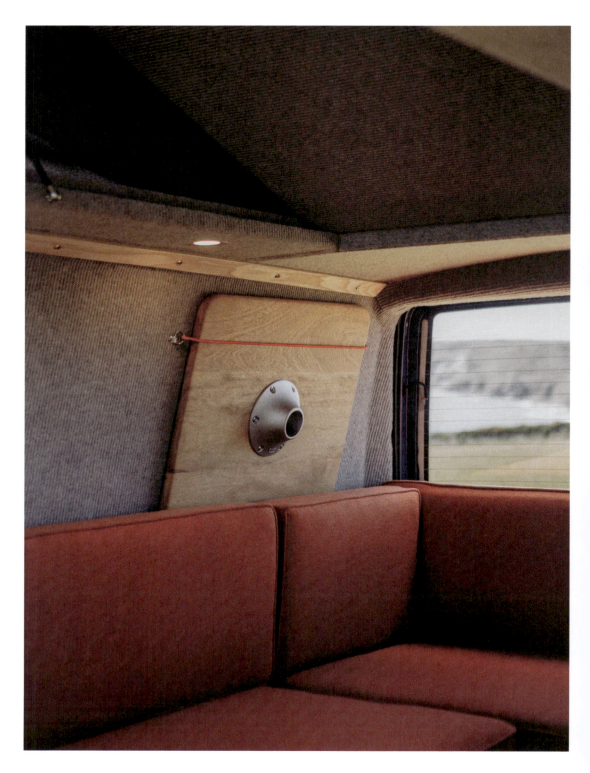

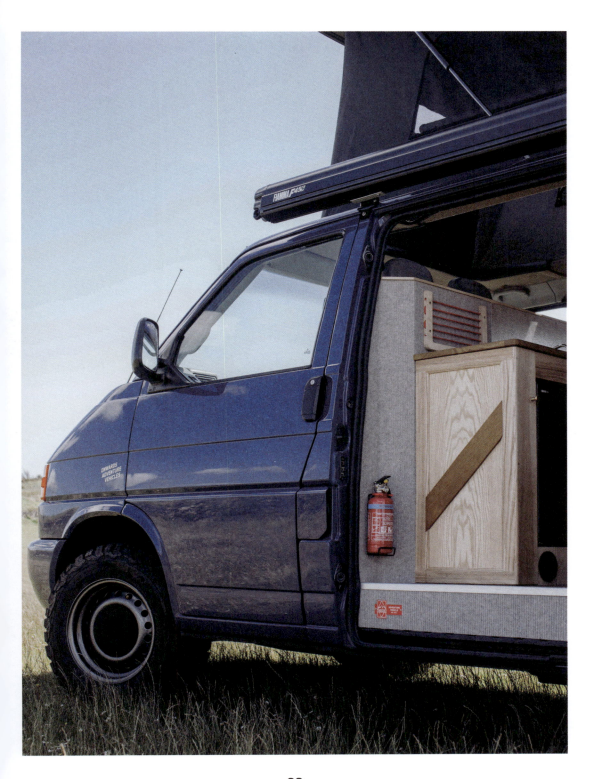

ESSENTIAL

PASSENGERS

BEDS

KITCHEN

SEATING

STORAGE

TOILET

SHOWER

LEAST IMPORTANT

HIERARCHY OF NEEDS

'There are no solutions, only trade-offs.'
Thomas Sowell

I love this pragmatic quote, as it will serve you well throughout your self-build. Imagine that you are attempting to distil the essence and purpose of every room in your home, and fit it all into a small space that moves on wheels. This is the challenge we face when building a campervan. Earlier, I mentioned key questions that I ask a customer. The most important of these is 'Who?'

Who?

When I receive the initial email or call from a customer, I first ask who 'they' are. Am I speaking to a solo traveller, or are they reaching out on behalf of a couple or a family? Will the group grow in the future? Individuals become couples, couples become families, families become couples again when the children have grown up and flown the nest.

Here we have our first chance to list the 'hierarchy of needs', a key concept that will reoccur throughout this process. The campervan must have the space and capacity to safely transport, house and sleep the people in the group. This tells us how big the base vehicle needs to be, how many seats the cab area must contain and if extra seats for driving need to be fitted to the habitation space.

Seats for driving

Your base vehicle will include driving seats as standard in the cab area. All panel vans are sold with a single driver's seat and one of two variants of passenger seating: a single passenger seat or a double passenger bench seat. These seats will be fixed securely to the structure of the vehicle, and will include three-point seat belts and airbags for safety. They will also have been rigorously tested to meet legal requirements. This allows for either two or three people to travel safely and legally in the cab.

In addition to this, extra seats for driving can be added to the rear habitation space. These may be similar to the cab seats, fold up out of furniture or consist of 'rock and roll' bed frames with integrated seatbelts. An example use case for these extra seats is a family of five, where three individuals sit in the cab and two sit in the rear when driving.

Beds

Beds for everyone are the next consideration. For adults, we define the minimum length of bed as between 180 and 190 cm. This ensures that when you are in bed, your head and feet have room to move. Understandably, everyone's sleeping habits are different, but experience has taught me that there is nothing worse than a bed that proves to be too short. Bed width can and will vary depending on whether it is a single or a double. I advise a minimum of 100 cm of width per adult.

Most beds are orientated lengthways in a campervan. This is due to the limited width of base vehicles. Shorter individuals may choose to sleep widthways in their vehicle and use beds that are less than 180 cm long. Some base vehicles also allow for the fitting of fibreglass 'side pods' to the outside, extending the width and ability to sleep widthways.

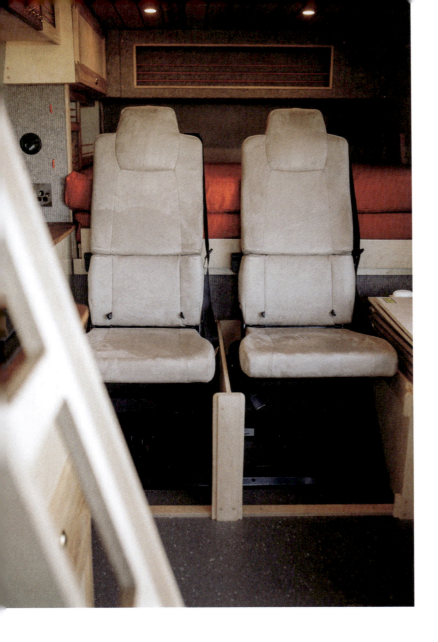

ADVICE

Folding travel seats offer extra versatility, easily hidden away in bench seats. These models are removable, meaning extra storage space when not required.

ADVICE

Swivel seat bases enable cab seats to double up a 'habitation space' seats when the vehicle is stationary.

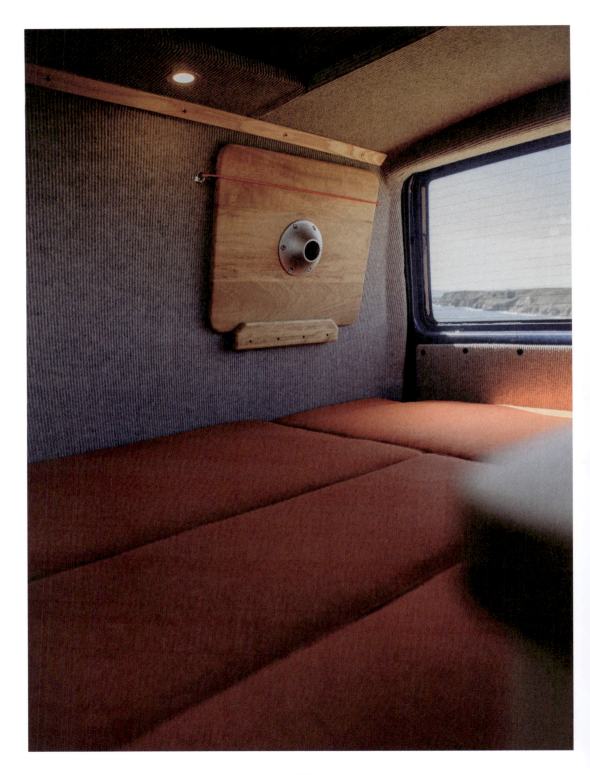

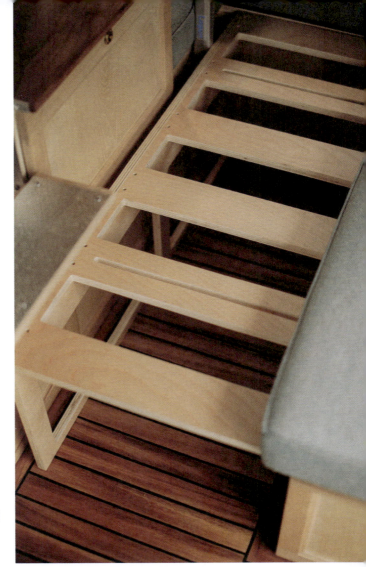

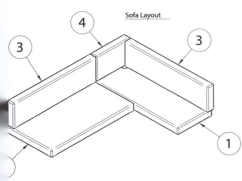
Sofa Layout

Bed Layout

ADVICE

Simplicity of the bed function will save you time and stress. Don't overcomplicate things. Design your seat upholstery to make up your bed mattress- saves space and money!

Elevating roofs or 'pop tops' allow for extra beds to be added in the roof area. This involves cutting a section of the steel roof away, adding a strengthening frame and fixing a shell, often fibreglass, to the roof via hinges and gas struts. The fabric tent is then fixed to the roof, creating a watertight extension. These are great for children or single adults. Cab areas also allow for beds designed specifically for children.

Fixed or pull-out?

One of the most common requests I hear is 'We want a fixed bed'. Having a dedicated sleeping area that does not have to be pulled out, set up at night and packed away again in the morning makes complete sense, but these beds take up a lot of space and offer little-to-no versatility. Smaller campervans traditionally have seating areas that transform into beds, either with pull-out sections, drop-down tables or various combinations of the two. Bed area design also depends on any driving seats in the habitation space. These may need to be incorporated into the layout to serve other purposes when the campervan is stationary.

A great option, and my preferred design route, is to use what I have coined a 'semi-permanent bed'. This consists of a large rear sleeping area with a smaller pull-out section. Usually higher than the benches or seating, this allows for a large garage.

space (we will come onto this) underneath. The benefit of this approach is that the bed takes seconds to 'make up' and doubles as a separate relaxing space during the day. Bedding and soft goods can be kept in place, minimising the frustration of having to change the dedicated seating into a bed. No one wants to be stressed before bedtime, right?

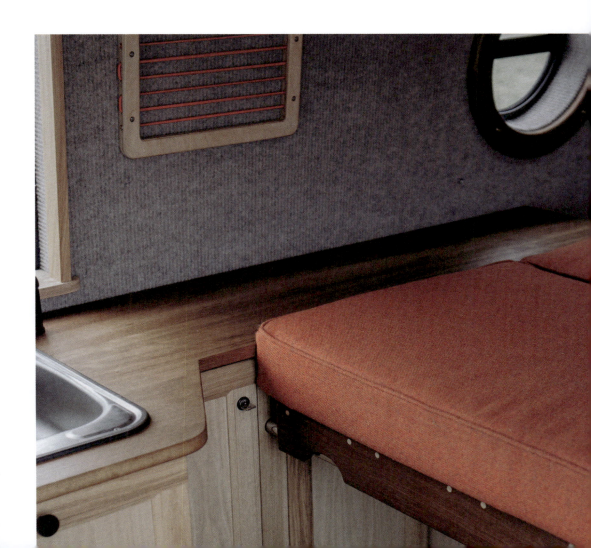

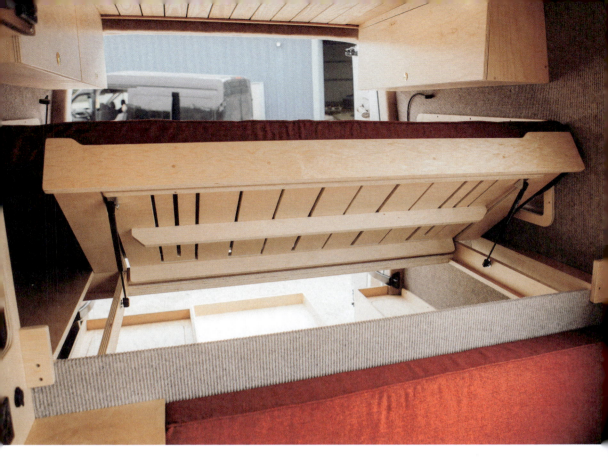

A rear 'semi-permanent' bed that raises to enable access to the garage space.

This 'L shape' seating area quickly transforms into a large bed. Simple but effective.

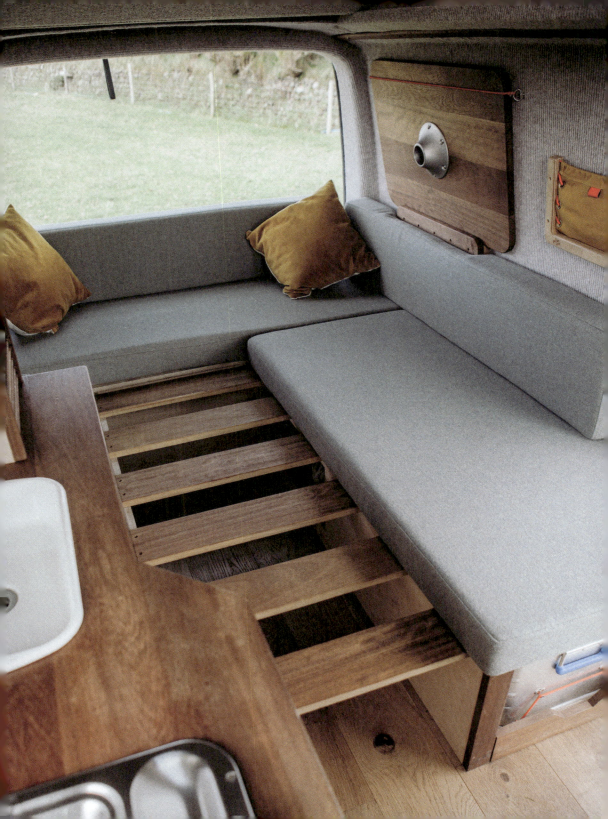

Where?

This seems like a silly question. Anywhere and everywhere, surely? In theory, yes, but in practice, there are places you will frequent far more often than others. You may spend most of your time parked on a dedicated campsite pitch. With access to mains power 'hooked up' and running mains water, a shower and toilet block, and a campsite kitchen. As I get older, I find myself enjoying this style of campervan travel more. I enjoy the reliability of a campsite, the relative comfort of a designated pitch that is level and sure to be peaceful. When I was younger, and maybe more intrepid, the wild camping approach appealed to me. Not paying a fee to park for the night and finding spots far from anyone else felt like a real adventure, not to mention slightly rebellious.

Regardless of your age, you may be wanting to travel like this. It is known as 'off grid' because you are independent of any infrastructure – you may have left the tarmacked road miles ago. This type of campervan travel requires a greater level of independence. It informs the choice and design of base vehicle: Do you opt for a more rugged vehicle with 4x4 transmission, modified ride height and suspension to deal with the more demanding terrain? Your habitation systems, namely power storage in the form of batteries and recharging capability, must be increased from what would be acceptable if you hook up to the grid to charge. The size of tanks for fuel, water and waste

must be considered. There also needs to be an enhanced level of preparedness, security and the ability to fix breakdowns and mechanical issues whilst on the road.

I would advise aiming for a point somewhere between these two extremes. Realistically, you want to build your campervan to handle one to three nights off grid, with the ability to take advantage of the amenities that campsites and designated rest areas offer. We will cover the habitation systems and design considerations that offer the best versatility and comfort in Part Three – The Build Process.

The terrain that you intend to travel through is also an important consideration. In northern Europe, where I'm writing this from, we have good road infrastructure, albeit the odd pothole. You can drive for hundreds, if not thousands, of miles on the road networks, reaching beaches, campsites and wild spots on flat, smooth roads. You may have to negotiate some gravel tracks, but a 'normal' front or rear-wheel drive base vehicle can handle these in dry conditions. If you intend to drive further afield, or into a wet field in the festival season, 4x4 transmissions, winches and grip mats are all worth thinking about.

I have built several campervans on 4x4 panel van chassis. They not only look the part but also offer the ability to 'get yourself out of trouble'. The trouble most likely being stuck in the aforementioned wet field or down a farm track, particularly during the wetter months. Tyres, traction and vehicle ride height will also play a role here. 'All terrain' and winter tyres, with more aggressive tread, will provide much needed grip if you do intend to negotiate rough terrain.

You cannot be certain where any road might lead you. Knowing what type of elements and terrain you might be faced with is highly recommended.

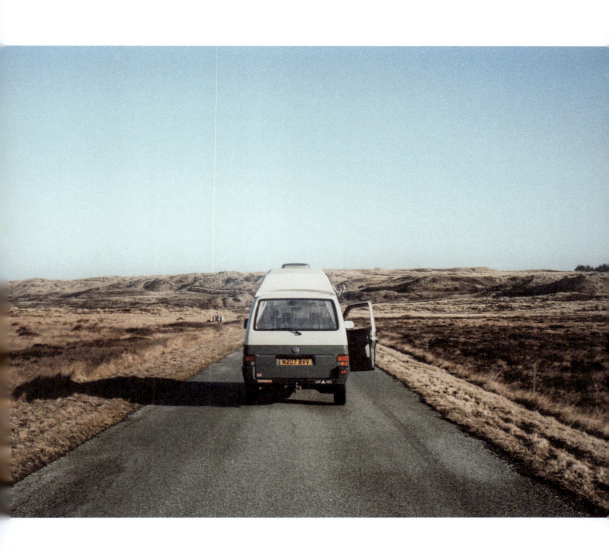

When?

In northern Europe, we experience four seasons: winter, spring, summer and autumn. The climate in the United Kingdom is relatively mild, with some rare extremes. As we face a changing climate, this will shift over the coming years, but for the most part we are very lucky. What we also benefit from in Europe is the access to a variety of environments. The various mountain ranges across Europe offer spectacular opportunities for mountain biking and hiking in spring and summer, and winter sports playgrounds in the colder months. If you intend to make the most of these beautiful regions, there are some key things to remember:

•*Insulation. See Part Three – The Build Process for an in-depth look into how to fit your campervan for optimum heat efficiency and regulation.*

•*Winterisation. Both the mechanical elements and habitation systems of your campervan should be protected from extreme temperatures. Pay extra attention to the insulation of external fittings, including water tanks and plumbing.*

•*Driving in cold conditions, particularly ice and snow, can be extremely challenging. Winter tyres and snow chains should be carried if you are intending to drive on uncleared roads.*

•*Outside of Europe, you may encounter more extreme weather and terrain. Voyages across large open areas such as the Australian outback and parts of Africa will require more planning, supplies and built-in redundancy. Any journey that will take you way outside of populated areas will involve serious risk. Carry extra equipment and water in case of mechanical breakdowns. You should also consider if your vehicle is capable of traversing extreme terrain before setting off.*

HOW YOU SPEND YOUR TIME

Now we will look at your campervan through a different lens. How you will spend your time in and around it.

Sleep

The importance of sleep cannot be overstated. It is the basis of a healthy and happy life. Of all the hours you spend inside your campervan, most will be spent sleeping. That is why I put it at the top of this list. Your campervan should be a quiet and calm space that offers welcome rest at the end of a day of adventures. This is best achieved with beds that are ample in size and comfort. We have touched on beds above. But here I will share some further considerations.

The structure of your bed, whether it is fixed or part of other furniture such as a bench that pulls out, needs to easily support your weight. This is especially important when two adults are sleeping on the same structure.

Traditionally, mattresses in campervans are made from foam, available in soft, medium and firm. The choice should be made based on your sleeping preference, but be mindful that beds that are made from upholstery that doubles as seating should be firmer than you think, to prolong their life. You can also decide to

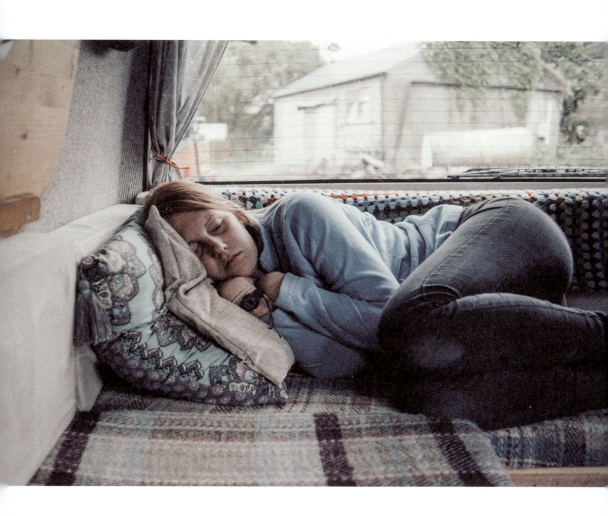

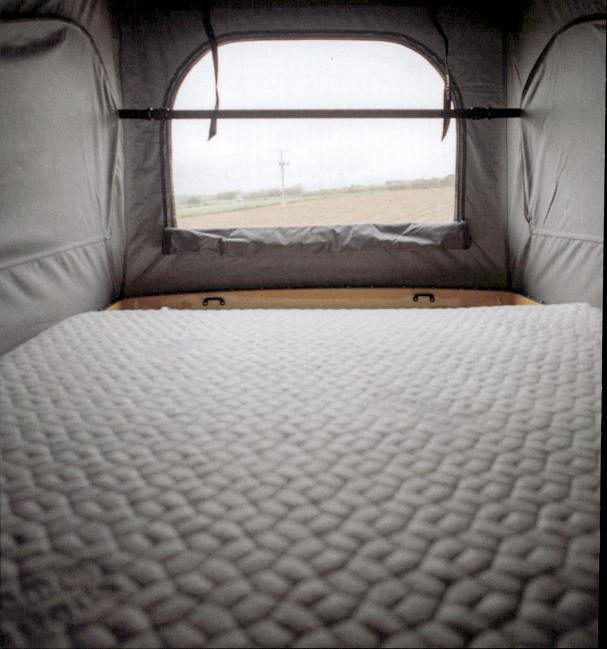

use more expensive purpose-made mattresses that are a blend of foam densities.

Air flow

Our bodies produce a surprising amount of heat when we sleep. This is transferred through the mattress to the materials that make up the supporting base. This is why beds are usually made using slats that allow air to flow underneath the mattress and minimise condensation. Mattresses supported by panels, such as plywood, will quickly become damp and potentially mouldy. You should use slats or create air flow by adding perforations to any supporting panels.

Fabrics and bedding

If your mattress, or part of it, doubles as seating, opt for fabrics with a high 'rub count'. These are designed to withstand increased use and will prove more robust over time.

Bedding in the form of sleeping bags or sheets and duvets can be tricky to store due to their bulky nature and the need to keep them clean and dry. Consider how you will store your bedding in your campervan. Dedicated storage spaces can be extremely handy and save time when making up beds in the evening.

Light, sound and temperature

Creating the perfect sleeping environment inside your campervan is achievable. Being able to restrict the amount of light that enters the space is crucial. This may be natural light if you are a late riser or artificial light if you find yourself parked near streetlights or in urban areas. We make blackout blinds and curtains that cover windows and vents. There are various ways that you can affix these blinds to your windows, including magnets, Velcro or snap fasteners. Some models of windows and vents will include blinds as standard. If you opt to make your own, add a layer of thermal insulation between layers of fabric to reduce the amount of heat lost through windows and vents, particularly in the cab area.

In your sleeping area, the panelling and thermal insulation added to the walls, floor and ceiling will help reduce noise coming in from the outside.

At this planning stage, consider the ventilation in your sleeping area. As a minimum, plan to fit at least one roof vent in the space and ideally a window either side that allows for fresh air to flow over the bed area. Sliding and top-hinge windows will allow you to 'dial' up or down the amount of air that enters. This will be particularly important during warmer trips when the outside temperature stays high, even at night.

Air conditioning is a viable option for those with the budget, space and power availability. Using electrical power to cool or heat air or liquids can be a power-hungry process. There are several roof-mounted air conditioning units available for campervans, most of which are designed to run when you are hooked up to the mains grid on a campsite. Others run on 12V DC power when off grid. Remember that the duration you are able to run such a unit will be limited by the capacity of your battery bank. We will cover power consumption in Part Three – The Build Process.

Rest

We will define rest as separate from sleep. This is time spent sitting or lounging inside your campervan, reading a book or listening to music. In other words, any time that you are awake but not in a state of movement. This is one of the defining factors in the level of 'cosiness' of a campervan.

Seating inside your campervan may need to serve multiple purposes. This might include safety while driving, support when working at a laptop, and space to relax into a less rigid position. Bench seats offer room for more than one person to sit next to each other, or are orientated in such a way that people can face one another and enjoy socialising. Seats and space to relax should be designed with you in mind. For instance, an avid reader may create a space that has an incorporated bookcase within arm's reach and be built with a folding table to hold plates and coffee mugs at lunchtime.

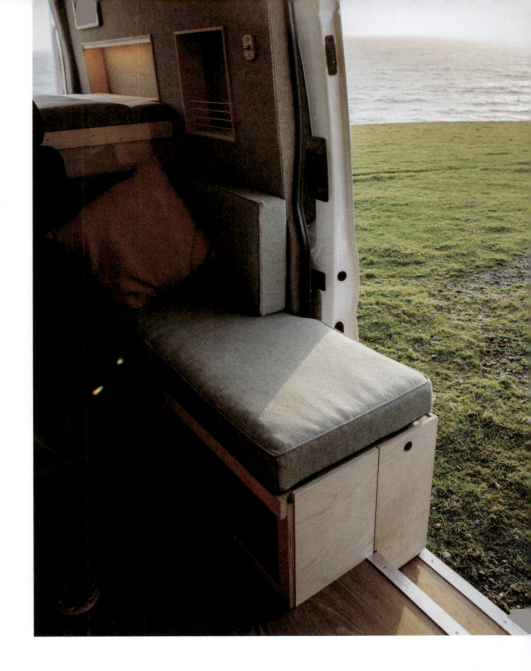

Create a seating area that is inviting. Where you want to sit and enjoy moments of comfort and calm.

Eat

My fondest memories in a campervan involve food. BBQs in French pine forests, packing away supplies from the markets in Portugal, the smell of eggs frying and coffee brewing. Food is so engrossing to the senses and always brings a feeling of satisfaction and well-being. Preparing meals and enjoying them in beautiful locations with people you love is about as good as life gets.

In order to make this an integral part of your campervan experience, you will need the following:

• *Ample room to store dry food goods, items for food preparation and fresh foods such as vegetables that do not need to be refrigerated. Think dry cupboard spaces that are easily accessed. Drawers at hip height for cutlery and racks and shelves for salt, spices and larger utensils.*

• *A fridge or cooler. Before I ever fitted a 12V compressor fridge to my campervan, I had a simple cooler that we would add ice to every day. It was cheap and worked, but we would be greeted with a growing pool of water as the ice melted. Prioritise a fridge in your design and budget. It will allow you to store fresh food for longer periods and enjoy all of the things in life that are better when cold: beers, white wine, vegetables, salads and fruit, to name but a few.*

• *Space to prepare food. A kitchen area that includes the above storage, space for a fridge and a sink for washing up. Tables and smaller units with work surfaces can make food preparation easier, which is always a good thing.*

• *Ventilation for the removal of fumes, smoke and smells created when cooking. Fit a vent (passive or forced – more on that later) in your main food preparation area above your kitchen unit.*

• Once you have enjoyed your meal, a handy space to dispose of the waste will stop your compact living space from becoming unnecessarily messy, dirty and cluttered. Large bins are impractical and let waste degrade in warmer climates. Include a small, easily removable bin that uses compostable waste bags and a space to store used plastic, cardboard and glass. This means that organic waste and recycling can be disposed of regularly.

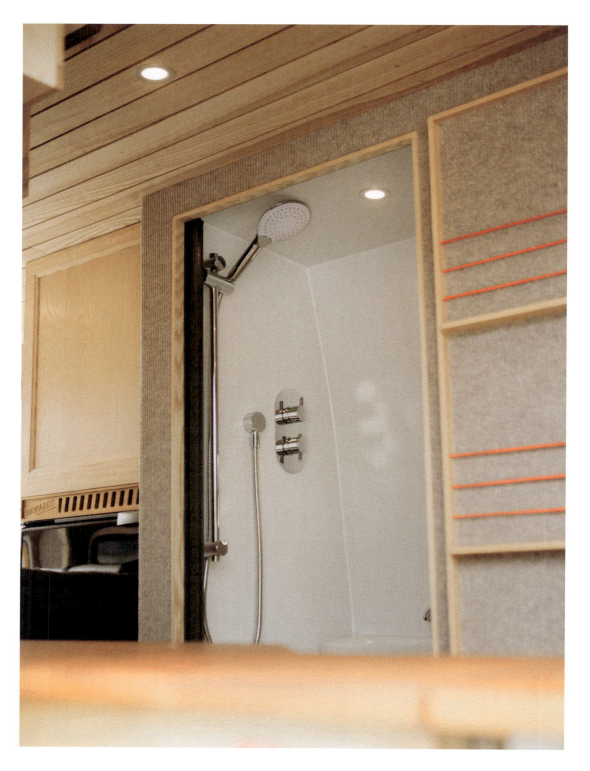

Wash

The open road has an uncanny ability to turn even the most highly polished and gleaming vehicle into a dusty and dirty version of itself. After a few miles of muddy roads, all of the hard work washing your campervan will have been in vain. Us humans work in much the same way: hours of driving and we are tired and a bit smelly. Salt water, sand, sleep and trappings of everyday life mean we must wash regularly. Personally, I shower twice a day, mostly because I enjoy the experience. Of course, your hygiene habits are your own, and this will dictate how important showers and integral toilets are to your campervan.

If you decide to include a shower in your campervan, first be mindful that your ability to carry water to service the shower is limited. Secondly, given the construction associated with showers, these units can be heavy and occupy a large space. By their very nature, they are prone to leaks if designed incorrectly. Ensure that you consider this thoroughly in your design.

Campervan showers come in many varieties. The simplest and easiest is an external shower connected to your habitation plumbing. Even if this does not serve as your main shower, consider including one in your design. They are perfect for washing off sandy feet after the beach, muddy bikes and grubby children. The downsides to this are obvious: exposure to the elements and a lack of privacy.

The traditional approach is a dedicated cubicle. A watertight box that allows you to stand at full height and shower just as you would in a domestic setting (of course, this is not possible in smaller campervans). These usually consist of a shower tray, waterproof walls and ceiling, a vent for the extraction of the warm and moist air, a shower head and a door that seals. This area can also double as a WC, with the inclusion of a toilet unit.

For the more adventurous designers, you may have come across the many different inventions on the internet: folding or sliding shower units, and shower trays hidden under bench seats that fold out and use a simple shower curtain. Many of these custom designs work really well, but the trade-offs are evident. If we again say the quiet part out loud ('your ability to carry water is limited') then it is worth reassessing your approach to including a shower. Any introduction of joints or moving parts will make waterproofing more complex.

Once used, the waste water from showers and sinks is referred to as 'grey' water. In most instances, you will be required to attach the shower waste plumbing to a separate tank for disposal at designated sites. Be sure to include waste 'traps' in your plumbing to reduce the foul smells that can travel back up the plumbing from waste tanks.

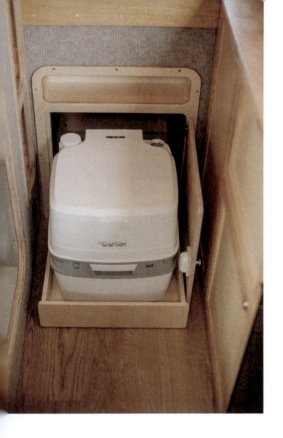

A hidden 'port-potti' toilet. Ideal if space is at a premium. This unit pulls out on drawer runners. Whilst not offering the privacy of a cubicle, it is ideal for emergencies or the middle of the night.

A dedicated WC cubicle housing a removable compost toilet. A luxury if you can afford the space. Where is this in your hierarchy of needs?

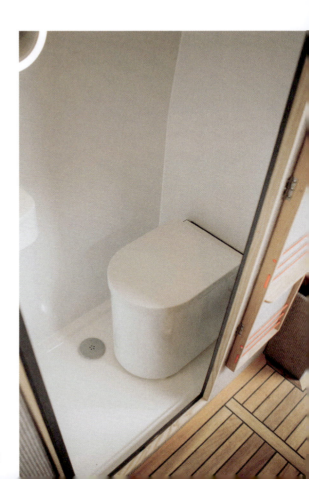

Play

The fun part! Let's face it, a campervan is an excuse to live life with more freedom and opportunities to play. To let loose, forget the complexities of our everyday commitments and routines. To take our leisure time, hobbies and passions with us. The kayak on the roof, the mountain bikes on the back doors, surfboards, card games, frisbees, tennis rackets – everything that facilitates play, even in adults. You will want to be able to safely and securely store all of the equipment you will use, either on the outside or inside of your campervan.

Roof racks are a great place to start. They offer a large, flat space for storing pretty much anything, but need to be designed around the items fitted to your roof (solar panels, vents, exterior lights and awnings). The best roof racks allow you to tie down objects of varying shapes and sizes, without compromising the use of the solar panels and vents. You will need easy access to your roof space. This could be via a ladder permanently fixed to the side of your vehicle or a folding ladder that is stored inside when not in use.

The second largest storage space is referred to as the 'garage area'. Many medium and large campervans have this area located at the back, with access via the rear doors, underneath the main bed. This space can house storage for your habitation systems

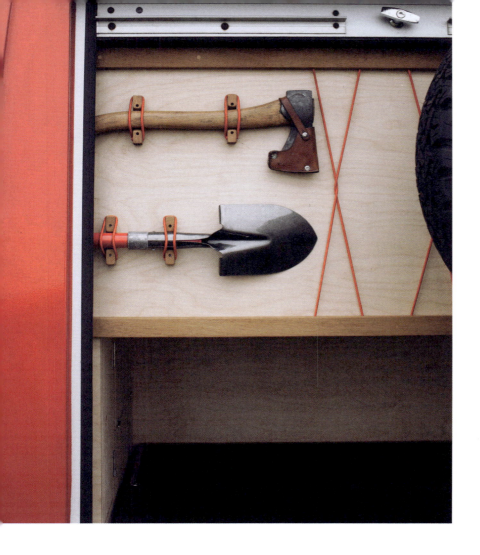

ADVICE

Storage of equipment is key. Include spaces dedicated to packing away items that would otherwise interrupt your living space.

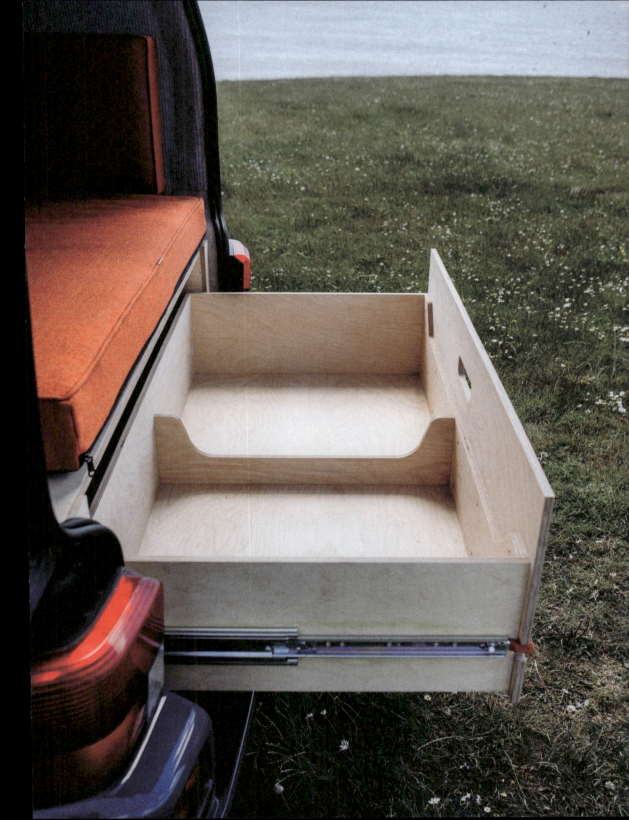

and your equipment. You will have seen the large pull-out drawers that allow bikes and other large items to be accessed easily. It also offers a space that is constructed to withstand more abuse than your main habitation space. It does not have to have a 'cosy feel' and can feature harder wearing materials and finishes to withstand moisture and dirt carried in on the items you store.

Now that we have covered the basic principles of a campervan, we will move onto how to prepare for your self-build project. Do not be daunted, at this stage your mind may be racing with ideas and inspiration, maybe things you had not considered. The multitude of details will come together as we take a closer look at how to plan and execute your build.

The rear garage area of a Mercedes Sprinter. An area designed to house the habitation systems alongside sotrage space for luyggage and equipment. The large drawer is for bicycles.

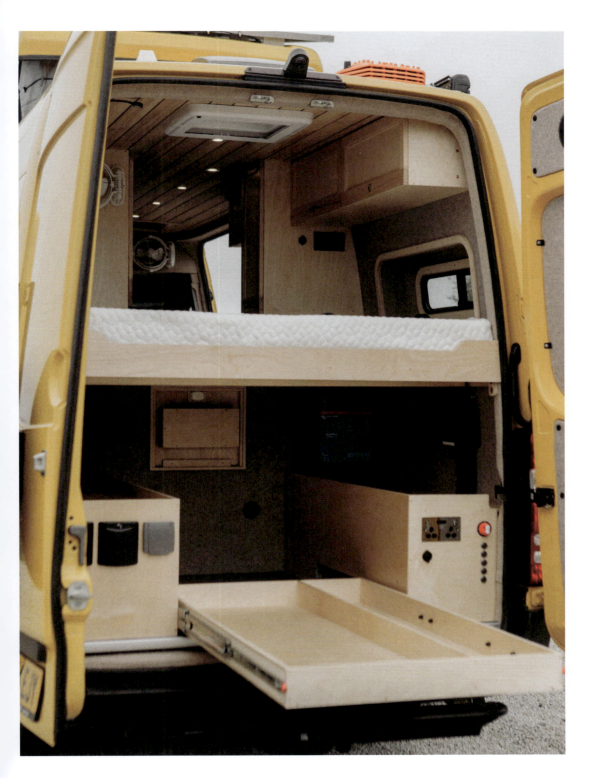

SELFBUILD CASE STUDY 01

+ some inspiration

Name: Sam & Meg

Number of campervans converted: 4

Campervan make & model: Renault Master MM35

Converted by: Myself

Used for: Trips ranging from a couple of nights to a month
Key conversion factors: Versatility of the campervan

Advice: It's easy to get bogged down with thinking everything has to be perfect, especially with the amount of time and influence we all spend and take from social media these days. My advice would be to see the van as a tool for your adventure. The roots of van life are very simple – a cheap and portable shelter to escape the trappings of modern life. I like to keep this in the back of my mind when a €50,000 4x4 Sprinter drives past me on the way to the beach. Having all that stuff isn't going to make your trip any more memorable or fun – it's all about people, places and experiences, and the van is a catalyst for getting out there!

I'd converted a campervan before but was now looking for more space. Having lived in a van for four years, I love the feeling of being able to take a little home wherever you go. In my layout, there's a permanent bed at the back across the van,

with lots of storage underneath. All the cabinets and storage are built with 12 mm ply to save weight and money, with a little extra structural timber where needed. There's a simple kitchen with no sink or running water, just some cupboards and a surface to chop and cook on a small two-hob cooker.

We surf and climb, so being able to fit our gear in without compromising living space was something I thought about a lot. I built two long storage boxes that can hold two longboards up to 10 ft and three shortboards up to 7 ft. They also provide extra space for bits and bobs, and form our seating area at the front. There's also a designated area for climbing kit, ropes, helmets, etc. Bouldering mats can also slide under the bed, along with the spare tyre.

Habitation Systems

It's a very simple technical set-up with six 12V ceiling-mounted lights and a leisure battery wired to a split charge of the main battery. For water, we just have a 50l tank in a cupboard we take out and keep on the countertop to act as a tap. I'm also about to (with the help of a kind friend) fit a diesel heater for warmth on cold nights.

Sleep

Having had a smaller van, where everything pulls out to make a bed, I really value having the space for a fixed bed in this van – it's a game changer when rocking up to a spot and not having to build your bed every night. We also have a small kiddo now who sleeps with us, so it needed to be big enough and safe for him too.

Rest

Space uninterrupted by outdoor equipment is important, so we can relax, cook and have a little bit of a zone to spend time in if the weather is bad or for a bit of a remote office if one of us needs to work on the road.

Wash

We get pretty dirtbag on our van trips! There's no toilet or shower in the van, so we just try to find somewhere to wash, or check into a campsite here and there as we go. We also usually spend a lot of time in the sea, which helps!

Eat

We hate throwing food in the bin, so we have a small container to keep food waste until we can dispose of it properly. We have a bunch of small cupboards for storing food, pots and pans, etc. I'm also teetering on the edge of investing in a 12V fridge. There's a pretty decent amount of countertop space in the kitchen from not having a sink, so that's nice for chopping and serving food.

Play

This is the key ingredient to our van trips – we are pretty much always going somewhere to either surf or climb, so making sure there is space for everything we need for these pursuits was one of my main concerns in designing the van the way I have. We can fit five surfboards in the van without affecting our living space, which is amazing, and we also have specific storage for climbing gear under the bed, but it's very easy to access.

Likes

Our van has been designed primarily to accommodate surfboards and climbing gear, but also to be a comfy, enjoyable place to hang out, and I feel like I managed to achieve that on a pretty tight budget, and by re-using a lot of material from my old van that died. I built a feature ceiling with strips of pine, which looks great and really adds a little flair of design, but apart from that everything is very simple and minimalist. It's like a combo of a bit rough and ready, and some parts I took some time on and pride in, and I kind of like it like that – nothing in my life is perfect, and my van definitely reflects that!

Dislikes

I think the electrical system needs work. I'd love a lithium battery and to integrate some solar and a fridge – these are all things I'll get around to eventually, but also these parts are often expensive. Just living within my means and enjoying the van for what it can give us now, as opposed to what it could be with an extra few grand thrown at it, is important to me.

Part Two

PREPARATION

It has been said, that a mountain's peak is reached only through many small steps. A seemingly mammoth task can be broken down into its constituent parts, and each approached with patience and the required preparation. I also find the notion of 'momentum' to be helpful. That as you stack 'wins': choices made, designs signed off, things constructed, tested and fitted, you will feel this sense of movement towards your end goal. In this chapter we consider areas in which you will have to make a decision based on your situation, available resources and chosen approach.

'Impatience is close to boredom but always results from one cause: an underestimation of the amount of time the job will take. You never really know what will come up and very few jobs get done as quickly as planned. Impatience is the first reaction against a setback and can soon turn to anger if you're not careful.'
Robert M. Pirsig

BUDGET

Everyone's budget is different. As you are building your campervan yourself, you can already define your time as a 'sunk cost'. As an investment in developing your skills and confidence, as we have touched on in Part One – Introduction. You may also receive help from friends or family, which can be valuable and speed up the process.

Your main expense should be your base vehicle, followed by chosen parts and materials. I often wince at the amount of money that we can easily spend on a campervan. I stand by my opinion that this type of travel is inherently attainable and should stay as such. Money is difficult to accrue, and anything you save on your build can be spent later on your actual adventures that the campervan is built for.

My suggested approach is to calculate your total available budget, use two-thirds to buy a base vehicle, and spend the remaining third on the parts, materials and consumables (paint, glue, fixings, etc.) required for your build. Leave a little aside for unforeseen costs.

The base vehicle is the foundation of your build. It would be a mistake to overly invest in one that may prove to be costly in terms of future breakdowns and mechanical repairs. Here are some key considerations:

• If you have the budget for a brand new base vehicle, you are covered by the original manufacturer's mechanical warranty, usually for a period of three years.

• Pre-owned vehicles, particularly private purchases, should be approached with added caution. In the UK, perform an HPI (Hire Purchase Investigation) check on the history of the vehicle. This will allow you to confirm mileage, outstanding finance and if the vehicle has ever been in an accident. The government's online MOT history-checking facility will allow you to check for any past failures, serious repairs and inconsistencies. In other parts of the world, rules may differ.

• Year of vehicle, mileage and service history will give you the best indication of how much 'life' the vehicle has left in it. High-mileage vehicles will require more repairs. Buying cheap, high-mileage models can prove to be a false economy when extra expenses are needed shortly after purchase.

The bodywork of your base vehicle should also be a serious budgetary consideration. Rust and damage can lead to deterioration over time. To rectify and repair bodywork, you will need to gain access to the inside of panels. This is made more difficult, if not impossible, by the fitting of your campervan interior.

With enough time and patience, there are some fantastic base vehicles available to suit every budget. If you decide to view and test-drive a vehicle, always be willing to walk away if it doesn't seem right. Call in a favour from a friend or a family member who has more experience buying vehicles. Another opinion and set of eyes can be of great help.

Example budgets

Small budget: €2,000–€5,000

A lot can be achieved with a small budget. I would avoid any ambitious base vehicles. Opt for something fairly compact: the larger the base vehicle, the more bodywork issues you may encounter. You will need to spend more time hunting for a deal and be realistic in avoiding those that 'seem too good to be true'. Keep your layout simple and functional. Spend your budget on simple systems while avoiding 'cheap' versions. Remember the myth of the false economy: buy cheap, buy twice. You can always add to your campervan in the future as your savings grow.

Large budget: €30,000– €50,000

A large budget gives you more options. Invest a large portion (more than 50%) in a reliable base vehicle. You will have access to a wider variety of makes and models. Take the time to pick the right one. Remember that even a big pot can dwindle very quickly if spent unnecessarily. Invest in materials, systems and finishes that stand the test of time. Prioritise those parts that will be used the most.

PROJECT PLANNING

There is a concept in the world of economics and project planning known as the 'inside vs outside view', developed by Daniel Kahneman and Amos Tversky. It suggests that we have a tendency to focus too much on the details of a project (time and cost), while overestimating its benefits (once complete). This is the 'inside view'. The opposite – the 'outside view' – is where we approach a project by comparing it to similar past projects, giving us a clearer understanding of the reality, unbiased by our overconfidence or optimism. I have been guilty of this many times and have somewhat overcome it by drawing on the data from my past build projects. Your own data will come from your experience, this book and conversations with others who have built their own campervans.

In Part Three – The Build Process, we will outline the separate sections of the build. Each of these sections will be slightly different depending on the scope of your build. These sections can be further broken down into specific tasks. To calculate a projected total timeframe for your build, assign an approximate length of time, in hours, that you think each task will take to complete.

A common mistake at this stage is to omit time taken to plan, design, source and store materials, clean and tidy your

workspace, and reassess when a task does not go as planned. This time, we will add a contingency. As it can be disheartening when your self-build seems to take longer than planned, it is key to be realistic with your intended timeframe. Even us professionals encounter unforeseen delays, mistakes and issues.

VEHICLE WEIGHT

In the United Kingdom and Europe, most panel vans have a gross vehicle weight rating of 3.5 metric tons. This means that when built and fully packed, including passengers, luggage and full tanks (fuel, water, waste), the vehicle must not weigh more than 3,500 kg. This is also the general international rule. However, some countries may categorise 'unladen, laden and gross' vehicle weights differently. Consult your local vehicle authority for clarification of the latest rules.

In the UK, car licences will allow you to drive a vehicle with this maximum gross weight. You will come across larger vehicles such as double rear-wheeled panel vans and overland trucks that may have a higher rating, such as 5,000 kg or 7,500 kg. You need additional licensing qualifications to drive these vehicles legally.

Safety

The manufacturer of your base vehicle designed the chassis to safely carry the maximum gross weight. This is stamped on a badge either inside the engine bay and/or the driver's door slam panel. This means that the structure has been designed and rigorously tested to ensure it can accommodate the maximum gross weight, while keeping all occupants safe in the event of

a crash. Overladen vehicles, those above the maximum gross weight, will suffer from greatly reduced braking capacity, the steering, handling and suspension will be compromised, and the vehicle will be uninsurable.

Licensing

Before undertaking your self-build, consult the vehicle licensing authority in your country. Determine the rules that govern self-built campervans or motor caravans in order to avoid mistakes or challenges with ensuring your vehicle can be legally converted and insured once complete.

There are also considerations with vehicle classification. In the UK, the vehicle testing and licensing authority will determine if a vehicle is classified as a 'commercial vehicle' or 'motor caravan', the latter being the preferred category as this allows for faster speeds on motorways and correct insurance categories. Your base vehicle, usually a panel van, will have been classified as a 'commercial vehicle' when first manufactured and registered. You will need to apply to the authority to have the classification changed. In the UK, this means that your build must meet a set list of criteria, and you must provide written and photo evidence of the changes you have made.

Some insurers will offer policies to cover your 'part or incomplete' campervan build. This can be handy for those who are using their self-built campervan during the build process. In the UK, all vehicles parked on public roads, even when not being driven, must be taxed and insured. For clarity and peace of mind, check the rules and regulations applicable to your country and geographical location before starting your build.

Determining your finished campervan weight

When it comes to weight, it is always important to know where you are starting from. The best way to do this is to find a local public weighbridge, weigh your empty base vehicle with you in as the driver, and make a note of the amount of fuel in your tanks and how much you, as the driver, weigh in kgs. Manufacturers will provide a weight of the empty vehicle, but doing the above removes any doubt. Once you have this figure, create a spreadsheet to calculate a total projected weight. Include the empty vehicle weight and the weight of the driver and passengers. Calculate these as actual or average adult weights. Even if you intend to carry children, it is good practice to anticipate average adult weights, as the vehicle is then able to carry adults, should the occasion present itself in the future.

Full fuel tank weight

Determine the capacity of the tank in litres and multiply this by the weight of your fuel. For instance, 1 litre of diesel weighs, on average, 0.85 kg.

Water tank weights

Determine the capacity of your water tanks (drinking and waste) in litres and multiply this by the weight of water. For instance, 1 litre of water weighs, on average, 1kg.

Other fuel tank weights

If your design includes a gas bottle (chassis mounted or lift out), include the weight of the liquid gas and the housing. 1 litre of LPG weighs approximately 0.5 kg.

Interior build

This should be a breakdown of everything you plan to add to the vehicle to build the campervan interior. For ease, use the categories from Part Three – The Build Process i.e. first fix, windows, vents, elevating roofs, lining and cladding, trimming, flooring, furniture, systems and external parts.

Luggage, equipment and food

This will be made up of everything you add to your completed build before a trip. Luggage will include clothes, bedding and soft goods. For equipment, think 'Play' – bikes, kayaks, surfboards and tools. Lastly, food means a fully stocked fridge and cupboards, even toiletries and a full toilet!

As you are doing your build, you will need to weigh each part before fixing it into your campervan. If your projected weight is above the actual weight, you are in a good place. If parts and materials prove to be heavier than you projected, you will need to make allowances for the extra weight in other areas or adapt your design as you build. We will return to weight later on in the book.

USA Following any permanent vehicle modifications, it is best practice to have your vehicle weighed and obtain a 'weigh slip'. This ensures your vehicle is not overloaded. Take a visit to your nearest inspection certified mechanic to obtain advice on any areas that may need to be addressed - seat belts, smoke detectors, carbon monoxide detectors, brake lights and positioning of license plates. If your base vehicle is registered as a commercial vehicle, you may be able to apply to the DMV (department of motor vehicles) to have it re-registered as a passenger vehicle, RV or truck camper. Specific rules are dictated by each state, so check with your local vehicle licensing authority before you start your build.

You will come to understand the compound effect of all of the materials and parts you fit to your vehicle; after all you will be lifting each piece into place yourself.

MATERIALS

'Materials choose you.'

Why do I like that colour? That texture? The way the light falls on the wall and casts shadows on the fabric?

Early in our business, I received samples from a traditional wool mill in the North of England. Fabrics in a range of tones that made me extremely excited. There was a burnt orange, a soft teal, a dark mahogany. These rectangles of tweed not only looked incredible, but they also felt soft and tactile. The fibres held an unapologetic smell of the earth. They arrived as a 'swatch', allowing for each colour to be compared to the next. I still have this swatch, and now give out cards with smaller squares of the fabrics for customers to choose which colour best suits their tastes.

I have used these fabrics ever since, particularly the orange. This colour has become synonymous with my campervan builds. I enjoy the way it picks up on the warmer timbers that we construct furniture with, iroko in particular. I match this with orange elastic cord in the storage areas, and against a backdrop of cord lining that adorns the walls and sometimes ceilings.

The materials that make up your build will dictate the colours and textures, and by extension, the tones of the light inside

your compact living space. You will have come across the visual tricks that patterns can play on our minds, how light colours in domestic settings, the location of windows and mirrors can trick our minds into believing spaces are far bigger than they really are. Even the design of the clothes we wear, like stripes and shades, can change the perception of our body shapes. I advise all customers to keep this in mind when envisioning their space.

Lighter coloured materials such as maple or birch-faced plywood, pine, white or cream paints and fabrics are great at achieving the above. The trade-off is that these are far more susceptible to showing dirt, grime and damage over time. If you choose to use darker materials like hardwoods, dark paint finishes, black or blue flooring and wall coverings, be mindful of how this will dictate the space.

Set aside time and space for the arrangement and storage of materials. The space and budget you have available will inform how and when you buy, store and use materials. My first campervan build, behind my dad's house, was a small Nissan Vanette. I had a modest budget of a few hundred pounds, after purchasing the van. It was the second vehicle I had ever owned. I knew that my budget would not go far if I rushed off to the homeware shops and started buying materials. Instead, I opted for the 'beg, borrow and steal' approach. Asking friends and family members if they had any leftover timber in their garages, politely scouring skips (with permission) for leftover materials.

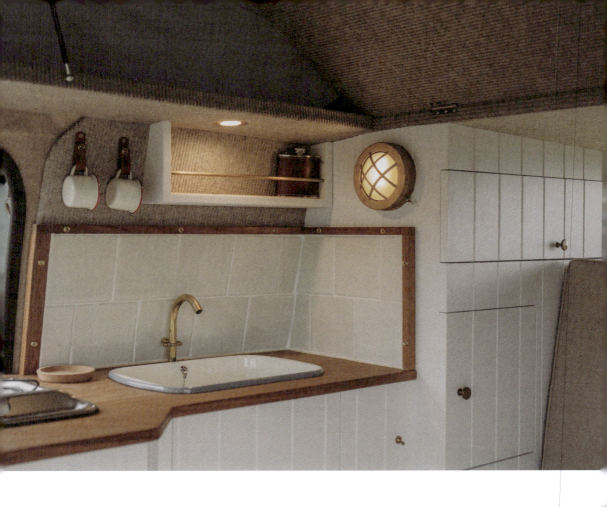

The choice and
combination of materials
reflects you.

It is surprising how much we store in our garages and sheds for later use, only for years to pass, and rolls of flooring or lengths of softwood to be forgotten about.

If you intend to buy most of your materials new, take the time to speak to suppliers and compare prices. Mainstream shops tend to add large markups to basic materials. Trade suppliers offer more competitive pricing and hold larger stocks. Ask friends if they have accounts with these businesses and buy using existing discounts.

When we start a large build at the Onwards workshop, I create a detailed list of all the materials required. Some we will already hold in stock, others we will need to order. If I go ahead and order everything at once, I need to be able to take delivery, unwrap, check over and store each item. Some, such as full plywood sheets and lengths of timber, will need to be arranged for later use. Lighter weight materials, such as insulation, are easier to handle and store.

We will cover specific materials that are used in different areas of your build in Part Three – The Build Process.

TOOLSET AND MINDSET

'Sharp blades require sharp minds.'

There is a well-known adage that 'a blunt blade is far more dangerous than a sharp one'. A sharp blade is predictable: with the correct pressure, it will reliably go where you expect it to, whereas a blunt blade tends to go wherever it wants. It is worthwhile remembering this throughout your handling and use of any tools. Proper maintenance and care taken to understand the intended use can save you time, money and your health.

Our workshop is full to the brim with machinery and both powered and manual hand tools. There is a tool for every task and some perform many different jobs. You may have access to a workshop or a well-stocked garage. Or you might have to make do with a basic list of kit. We will start by taking a closer look at the essential tools, from the most basic, providing a short description of their most common uses when building a campervan.

Once you have an understanding of the design of your campervan, you must then ask yourself how you are going to construct each part. There is a process involved, the tools that enable that process, and the materials that will be modified and transformed. Knowing beforehand which tool you require, and when, is key.

'Work smart, not hard.'

Tips for Tools

- Some tools, such as saws, knives or drills, require parts that will be replaced over time: these include blades, cutting edges and drill bits. It is worthwhile keeping a good stock of replacements to minimise any 'downtime' taken to fit new parts.

- Consider the maintenance and storage of your tools. If you are investing in kit, you will prolong its life considerably by keeping tools in categories, away from moisture, dirt and dust. Clean each tool after use, allowing you to simply pick it up and start using it with minimal interruption.

- As some tools are battery powered, choose an area where you can create a 'charging station'. If you have multiple batteries, cycle these so that when one is depleted, you can replace it with a fully charged one and carry on with your task.

- When I am in my workshop, I wear a tool belt or work trousers with pouches and pockets. During your build, you will be climbing all over your vehicle (and under it). I usually prepare for a task by organising the tools needed and collecting any hardware (screws, nuts, bolts, etc.) in the pouches and pockets. I ask myself 'once I am up that stepladder or under the van, do I have everything I will need to perform that task?' Jumping in and out of your vehicle or up and down stepladders can be time consuming and lead to a rushed job, or an accident.

Essential campervan tools

Carpentry pencil
A carpentry pencil differs from a normal pencil in its profile. The rectangular shape provides two larger sides with which you can easily align and mark out surfaces. The pencil lead shape lends itself to straight lines for marking out, measuring and cutting.

Retractable tape measure
A retractable tape measure sits easily in your pocket or tool pouch. Most extend to a maximum of 8 metres. Perfect for capturing dimensions when designing your interior and marking out for cutting of materials.

Straight edge
A straight edge, usually aluminium or steel, gives you a guaranteed straight line when marking out. It also assists with measuring profiles, where turning a shape into a compound of straight lines can be quicker and easier than scribing curves.

Set square
A set square enables you to mark out lines at a perfect right angle from the side of materials. This makes cutting straight lines correctly, by hand or with power tools, easier.

Hex spanner set

Many of the factory bolts inside a vehicle are hex-shaped. A hex spanner set will prove invaluable when removing trims and other vehicle parts during your build.

Allen key set

As with the spanner set, no campervan toolkit is complete without an Allen key set.

Torx bits

Torx bits differ from Allen heads: they form a star shape and can be found in many trims and fixings.

Sharp scissors

I stress the 'sharp' part here. A keen bladed pair of scissors makes cutting fabrics, trim materials and even insulation much easier.

Craft knife (with fresh blades)

A craft or Stanley knife with a supply of fresh blades: these knives are used for trimming materials and sometimes for making accurate marks in timber for chisels to follow. The shape of the knife will help with cutting materials against straight edges. Take extra care when using these knives as they can easily slip and cause serious injuries.

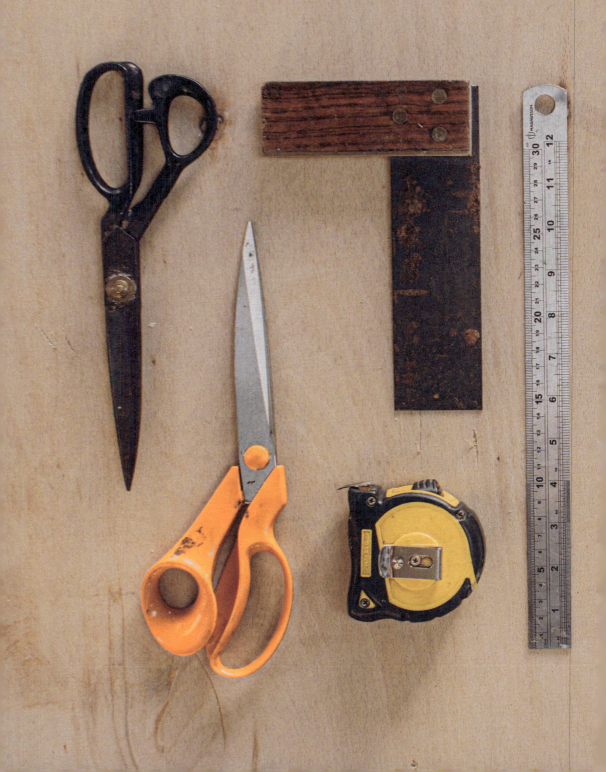

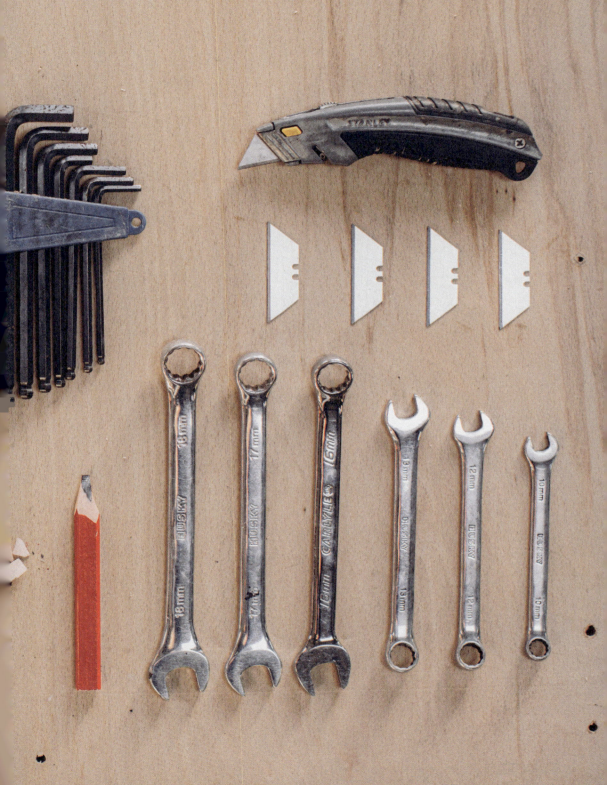

Chisel set

These specialised tools can remove material to create joints and tolerances in timber. Combine them with a wooden mallet for controlled, safe use. The blades have a sloped edge and should be carefully sharpened using wet stones.

Japanese saw

Traditional Japanese saws cut on the pull motion, making them great for quick, accurate cuts and trimming lightweight materials.

Battery-powered jigsaw

This is perhaps the most used tool in our workshop. The battery-powered jigsaw cuts contours and tight curves in panel materials. I use it to make quick adjustments to ply lining and other trim pieces.

Circular saw

Our circular saw is used together with a 1.5-metre rail. The saw slides along the rail, producing straight cuts in panel materials or hardwood boards.

Mitre saw

This powerful saw is designed to cut across the grain in lengths or planks of timber. It will also cut accurate angles for mitre joints.

Hole saw set

Hole saws are available in a variety of diameters. They usually fit into an arbour, or mount, and can be used in a battery-powered drill to cut holes in wood, plastic and metal. They are also used to cut holes in the floors and roof of a vehicle to allow for pipework and wiring to enter and exit the habitation space. They usually leave a rough hole that must be cleaned up afterwards.

Nibbler

One of the sheet metal tools in our workshop, nibblers are available in battery- or air-powered versions. As the name suggests, the nibbler works by quickly punching small pieces of metal out of a sheet. The nibbler is a fairly accurate way to cut apertures for windows and vents in the single skin steel on the side or roof of your vehicle.

Air panel saw

My preferred way to cut sheet metal, the air-powered panel saw works much like a jigsaw, with a fine-toothed blade oscillating at high speed. The air versions offer more power and the orientation of the tool and blade enables you to cut tight curves. The saw will also cut through double skin steel.

Hand file

This tool cleans up metal edges by grinding away any pieces left over during the cutting process.

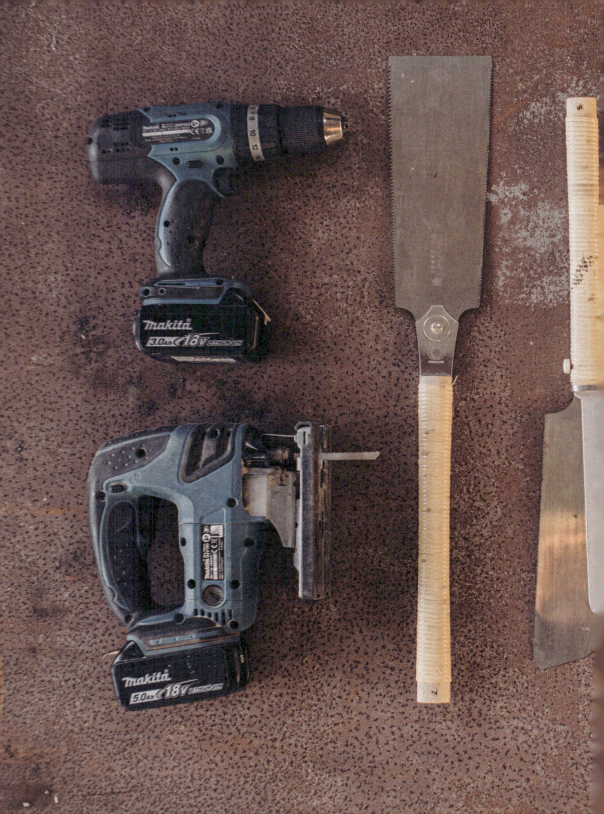

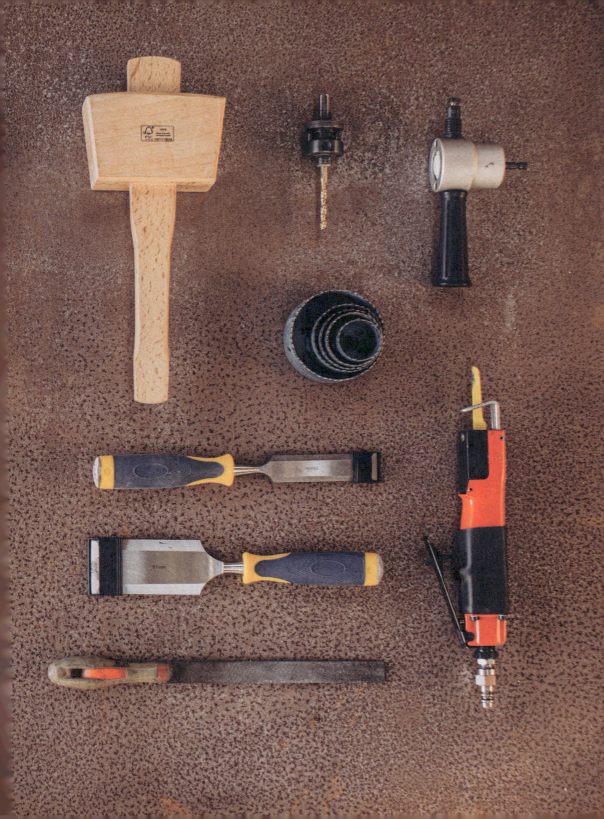

HSS drill bits

High-speed steel drill bits are designed to cut through metals, particularly the steel that makes up most of the chassis and bodywork of your vehicle. They can also be used to cut through composite materials, including plastics. Some materials, such as stainless steel, harden when heated and will require cutting lubrication and slower revolutions per minute (RPM) when drilling. You will use these drill bits in handheld drills and bench-mounted pillar drills when creating pilot holes or opening up panels before using cutting tools for window and vent apertures.

Wood drill bits

These differ from HSS drill bits in shape and design. The tip has a central point that guides the drill bit through the softer timber. The outer blades cut through the wood fibres as the drill bit rotates. When cutting through timber, ensure that the back face is supported by a piece of waste wood to stop the drill bit 'bursting through' and splitting the material.

Burr removal tool

Used together with the hand file, the burr removal tool cuts away burrs, sharp pieces of metal on a cut edge, by running a tempered steel curved blade along the cut edge at an angle. These tools are useful when cleaning up circular holes cut with a hole saw.

Sealant gun

Tubes of sealant and adhesive are mounted within the frame and the trigger forces a plunger to squeeze the contents through a nozzle. We use these when fitting vents, windows and sealing inlets for electrical hook-ups and water fillers. They can also be used to seal shower cubicles, sinks and worktops using silicon. There is a real art to using these guns: slowly does it, and patience is key.

Various clamps

One-handed clamps are the most versatile. These will be used to hold materials in place while you add permanent fixings. They can also be helpful during furniture construction. To avoid the clamps marking materials, use small pieces of sacrificial timber between the clamp and the material.

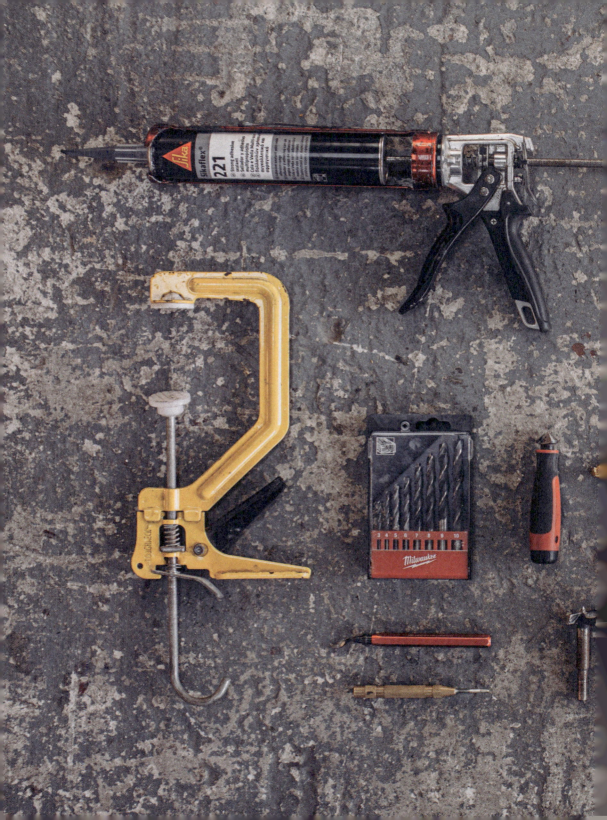

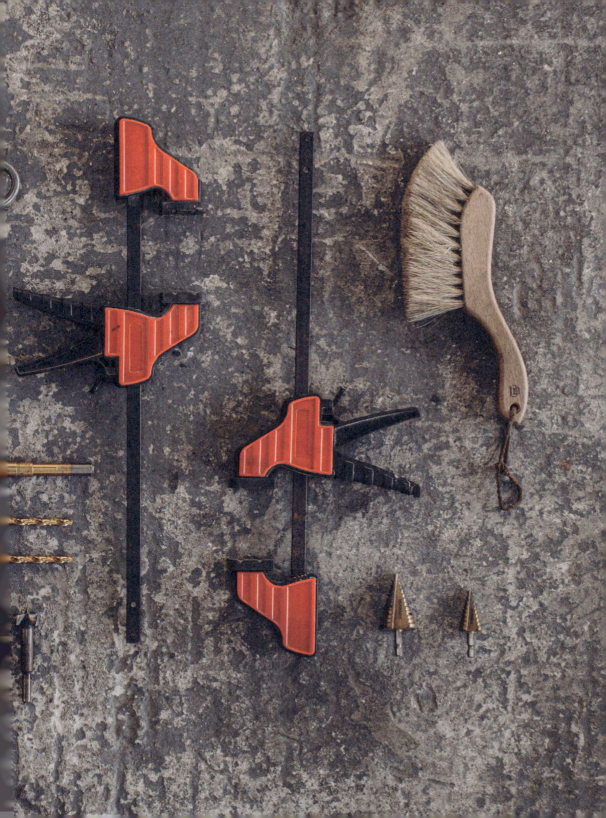

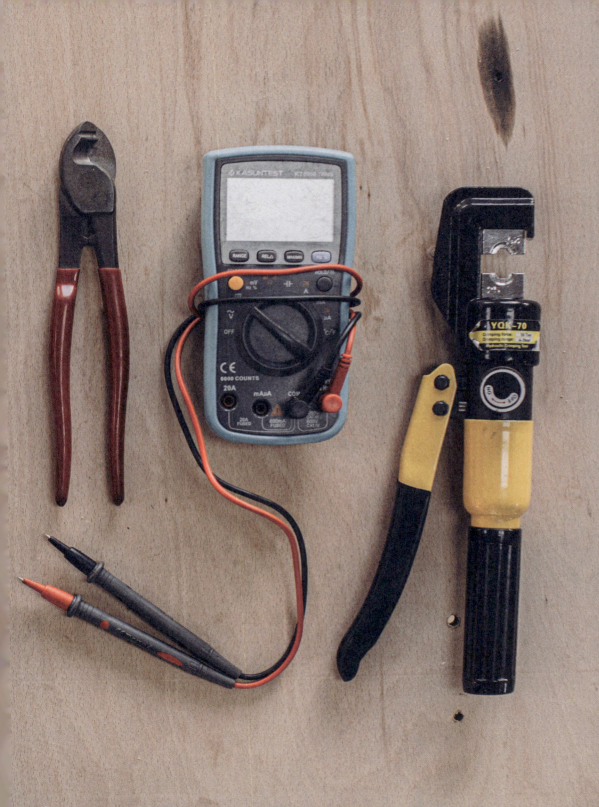

Consumables

This section covers anything you use to paint, glue, clean, seal or protect materials during your build. Many of these liquids can be harmful and flammable, so store them correctly and carefully. Always read the labels and follow the correct safety procedures. Protect your eyes with goggles, hands with gloves, and your respiratory system with a mask.

Quick glazing primer

This primer was developed for the automobile glazing industry, for fitting or replacing windscreens. It is the perfect primer to use when cutting through the steel of your base vehicle because it dries in minutes and protects bare steel against rust and corrosion. Apply it using felt applicators.

Sikaflex

A PU-based sealant and adhesive, Sikaflex is a staple in the campervan conversion industry. This product is available in a range of options and is mainly used for sealing and bonding vents and windows in place. It is UV resistant and remains semi-flexible to minimise cracking with age.

White spirit

White spirit can be used to clean up most solvents and oil-based paints. It is useful when working with PU adhesives and sealants and cleaning brushes of solvent-based paints.

High-temperature-resistant spray glue

This can be bought in small cans and large canisters. Spray contact adhesive is used to bond carpets, fabrics and other trims to plywood panels and the steel structure of your campervan.

Water-based wood glue

Used to bond soft and hard woods. I use wood glue with other fixings to ensure strong joints for furniture, particularly structural parts such as seating and beds.

Mitre glue

Two-part adhesive used for rapid bonding of woods and plastics, ideal when constructing trims that are not subject to large forces. Or to hold materials in place while you fix them together using screws.

Clean rags

Ideal for cleaning and applying oils for finishing timber. Make rags by cutting up old clothing or buy boxes of them from your local paint supplier.

Masking tape (low tack)

Used for marking out and protecting paintwork when cutting and drilling. Avoid cheap masking tape that can prove difficult to remove. The premium low-tack options will save time and avoid damage to paintwork.

Plastic sheets

Plastic sheeting is available on a roll and it is good to look for the recycled version. We fix this, using masking tape, to the sides and interiors of vehicles when cutting and drilling. It avoids swarf and sparks from settling on bodywork and damaging interior plastics or trims. You can also use it to separate areas of the campervan, such as the cab, when your workspace is dusty.

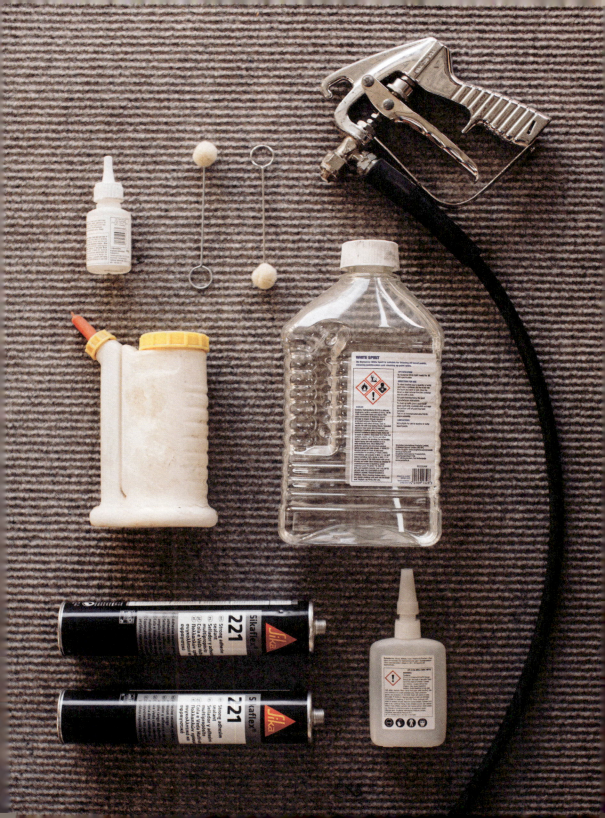

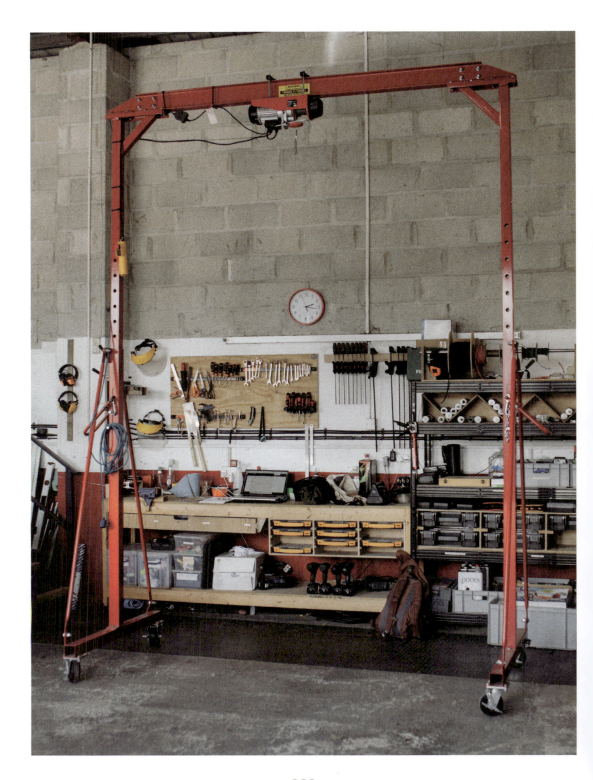

WORKSPACE

Before you start work, and once you have your tools sorted, you must prepare your workspace. I started out in my dad's garage, with the van parked on the road in a housing estate in the UK. My first consideration was the weather: what limitations would rain and wind put on my ability to tackle certain tasks? I would have to avoid cutting any apertures for windows and elevating roofs or vents if there was a chance that the heavens would open. I also didn't want any tools or materials left out in the open to be damaged by moisture. How much space inside the garage would I be able to use once I filled it with parts and materials? Smaller spaces require a kind of juggling act.

Once I had a plan for the weather, I considered how the noise and dust I created might affect my neighbours and restrict my work to more acceptable hours. Was the ground sound and level enough for me to jack up the vehicle and safely support it with an axle stand for any work to be carried out underneath? What clothes and protection would I need to wear to make sure I didn't get unnecessarily covered in grease and grime? Pre-owned vehicles can be especially dirty underneath.

My first professional workshop was in a small Cornish fishing village, where I would contend with fish deliveries and all the sounds and unpleasant smells associated with that. In essence,

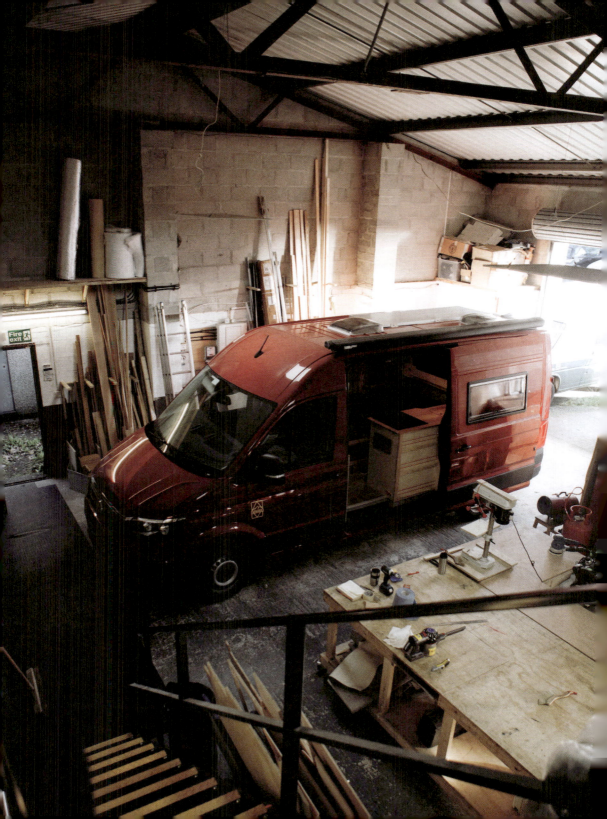

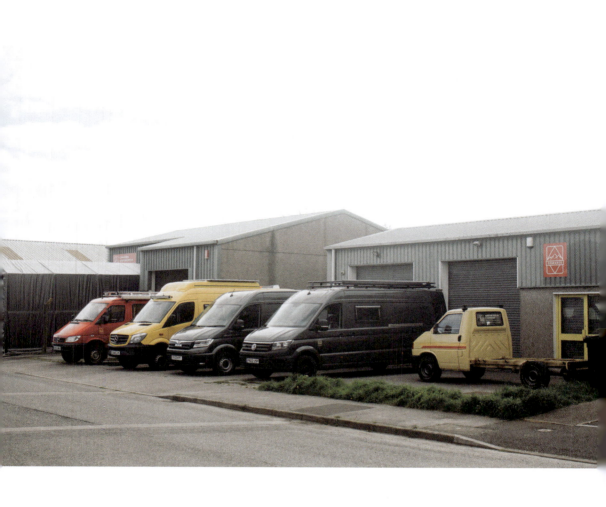

A line up of campervans and vehicles awaiting transfomation outside of the Onwards Workshop.

I signed a six-month lease on a large garage where, when it rained, the inside wall would turn into a waterfall and drain inside. It was dark, damp and dingy, but it was a space that I could make my own. I built my first few customer vans in this space. With just enough room for one vehicle at a time, a main workbench and storage racking. I would play the game of Tetris – moving one thing to fit in another.

Count your lucky stars if you have access to a larger space that you can park your base vehicle inside and work on, such as a large workshop, barn or unit. Areas that allow you the space to set up workbenches and shelving for storing tools and machinery are great. They will make your build more efficient. Consider where you will store and dispose of your waste and offcuts. It is surprising how quickly a workspace gets cluttered with parts in various states of assembly.

Now for the actual build. The decisions are made, the designs are on paper, and it is time to pick up those tools and make some noise and dust. It will be beneficial to read through this next section before actually starting work. It has been formatted to cover the majority of tasks you will undertake. We will give an overview of the processes, and it will be up to you to adapt these to your project.

SELFBUILD CASE STUDY 02

+ some inspiration

Name: Andrew & Emma

Number of campervans converted: 2

Campervan make & model: Mitsubishi L300 Delica Starwagon 2.5TD

Converted by: Myself with help from my partner, Emma

Used for: Trips ranging from 2–4 nights to a week or more

Key conversion factors: Budget, Number of travel seats, Exterior look and feel of the campervan

Advice: Don't be intimidated by all the amazing and expensive high-end conversions out there – it's possible to create something functional and beautiful on a low budget. Also, think hard about what you actually want to use the van for before building.

I'd built a van before and was looking to improve on my last conversion, but I still wanted to take a simple approach. Our inspiration was to build something that would allow us to use the van to carry passengers as well as be functional for trips away. We enjoy having a space to retreat to after hiking adventures and somewhere to eat pizza whilst watching the sunset, so we wanted to build something as simply and cheaply as possible that would still look good and be functional.

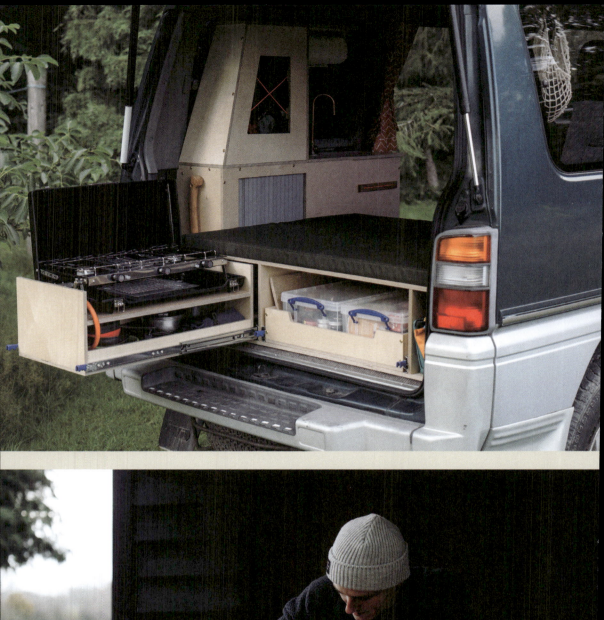

I'm a woodworker so the choice to self-build was an easy one, plus our budget wouldn't allow for any external help. I think our build shows that you can create something functional with very little money and time, and serves as inspiration to those who feel that converting a van could be too complicated or expensive.

Our layout consists of a simple platform at the rear of the van with under-seat storage. We cook outside under the tailgate. The rear seats fold down to meet the platform and make our bed, and we have a small cupboard and sink with 12V tap for brushing teeth. Our set-up is all about simplicity. We also have a roof tent that serves as extra sleeping space. Emma, our seven-year-old son and I can just about all sleep in the van, but the roof tent gives us more space.

Sleep
This is the least successful part of our build. The sleeping area is slightly too small, but we never intended on sleeping in the van for many nights in a row, so it works for the kind of trips we do.

Rest
This is where our little set-up excels – we can quickly turn our normal vehicle into a space for sitting, relaxing, eating and sheltering from the weather. The rear seats lift up and over themselves to make them rear-facing, and between them and the raised platform we have a table that in theory four people can sit at. It's a small space, however!

Wash

We don't have any complex systems: just a small 12V tap, which is powered off the main battery, and a sink. Water storage is in two 5l jerrycans inside.

Eat

We cook mostly outside under the tailgate – we have a gas stove that extends out on heavy-duty rails, and do all food prep either inside at the table or outside at the rear of the van. The way we use the van is really as an extension of our camping set-up so we typically cook simple food. Our van is a way for us to spend more time outside, so this set-up works well, although it's not so good in the rain.

Play

The van itself exudes playfulness – that's what drew us to these vehicles in the first place. Our original expedition roof rack gives us storage for all the muddy / dirty / wet equipment like hiking boots, camping gear and wetsuits.

Likes

We like the seating area – it's small but super cosy and we have many happy memories of eating snacks and drinking beers as we watch the sun go down or listen to the wind and rain lash against the windows knowing we are safe and warm in our cocoon.

Dislikes

We would like to have fitted a diesel heater, but the small space made it complicated and expensive. There are lots of things that were complicated by the size of the van and our need to keep rear seats.

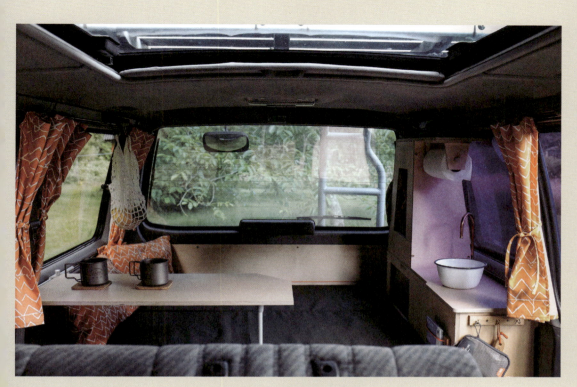

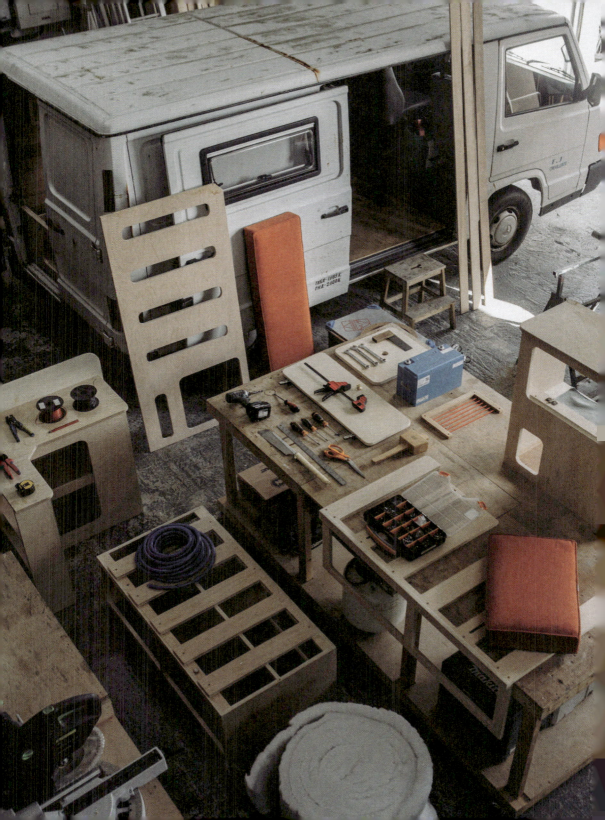

Part Three

THE BUILD PROCESS

In this part of the book, we will cover the fundamentals of the build process of your campervan. There may be elements that fall outside of this list, but this will give you an intermediate understanding and level of knowledge to pursue your own self-build. It will also give you a structure on which you can base your project.

There is an ideal order in which these tasks are performed, so as not to make your project unnecessarily difficult. We will first look at vehicle preparation, then on to 'first fix'- as the name suggests, this is where you will lay down the foundation for the rest of your build. The steps that follow will consist of covering up a lot of this initial work, although it will be hidden, it will make up the solid foundation for your campervan.

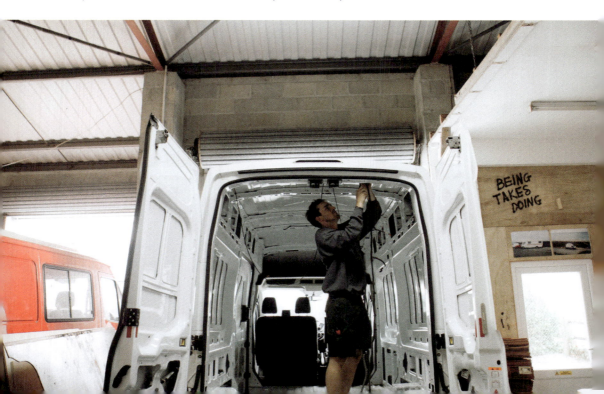

VEHICLE PREPARATION

The first few hours at the workshop are always spent clearing out and cleaning the interiors of the van and removing any dirt and dust that will hinder the build process. This also includes retrieving any items left under seats or in door storage pockets. Items that have been forgotten usually include pens and coins from previous owners. But this wasn't the case while we were clearing out an old ambulance from Slovakia (a Volkswagen 'Syncro' T25 in cream with factory high-top). Given its previous life, it had a lot of ambulance hardware still in place, and in one of the cupboards we even found a straitjacket! It turned out the owner knew it was there and wanted to keep it for provenance purposes.

To properly prepare your vehicle for the build, give it a thorough clean inside and out. You'll need a vacuum cleaner, bucket of warm water and soap, and a sturdy pair of gloves! Most pre-owned base vehicles will have accumulated a lot of dirt and dust, particularly behind door cards and under cab seats, matts and subfloors. I have cleaned up more dried coffee spills under drivers' seats than I can count!

This is also the first chance to get inside and start to transform the space. Remove any handles and hardware items not required. Ex-delivery or -utility vehicles may have aftermarket lighting or

other parts fitted. Remove these and set aside- you may be able to re-use them in your interior. During this process, you may uncover bodywork issues, such as surface rust where moisture may have collected. It is at this stage that you want to discover any curve balls and tackle them before progressing.

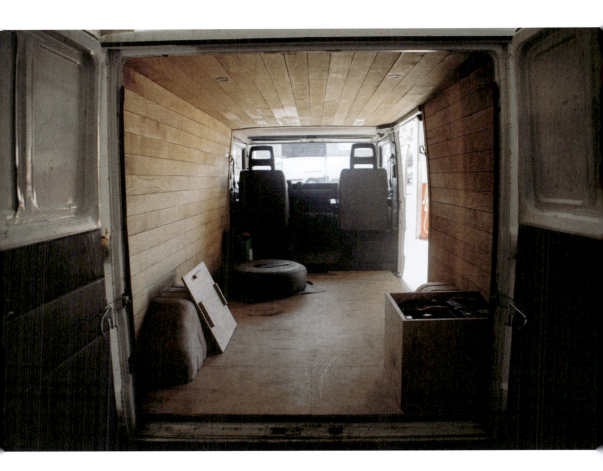

Old Interior of a Mercedes MB100D before a furniture upgrade.

FIRST FIX

The term 'first fix' is taken from the building and manufacturing industries. Once you have a clean blank canvas, first fix refers to the tasks that will lay a solid foundation for the rest of your build. As you construct your interior, areas of the space will be enclosed by sound dampening, insulation, cladding, trimming, flooring and furniture. Depending on how you design these aspects, access later on may be a challenge. In order to minimise this, think of how to future-proof your build.

Conduits are the best place to start. Use flexible versions to allow for easy running of wires, cable and pipework behind wall cladding, flooring and the ceiling. These also protect cables from sharp metal edges. Place extra runs of conduits in areas where you may later add more wiring and put 'chase wires' in these conduits to allow you to pull cable through later. Pay attention not to create tight curves in these conduits.

The first fix is also the stage to cut any holes or apertures in the floor area. These will allow for fitting of gas drop-out vents, and habitation cables and pipework to enter and exit the space. In this stage, we will also cut holes and fit inlets for tank fillers, hook-up inlets and holes in the floor for any services. Remember to clean the edges with your burr removal tool and sandpaper, and coat cut edges with glazing primer.

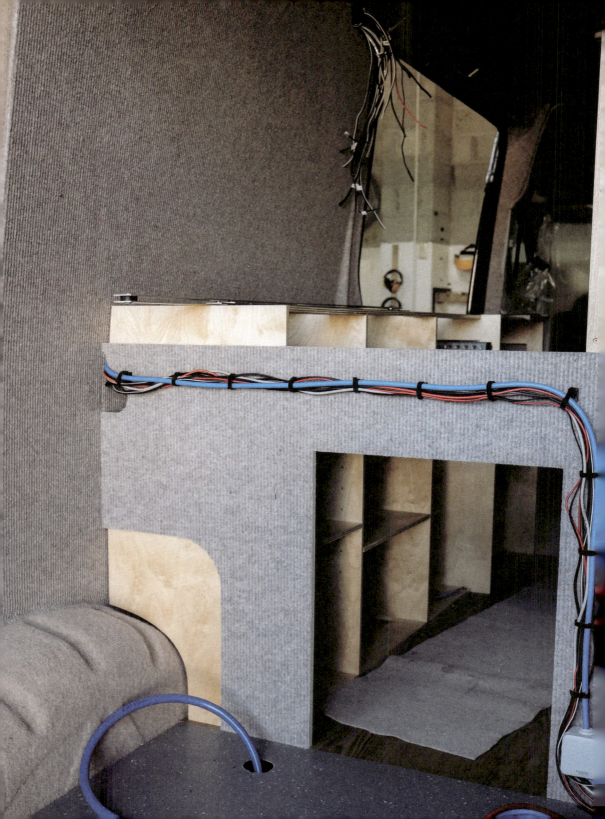

Softwood battens bonded to steel floor, creating a cavity for insualtion and a fixing point for 12mm plywood subfloor.

Once subfloor if fitted, first fix wires are tidied and checked.

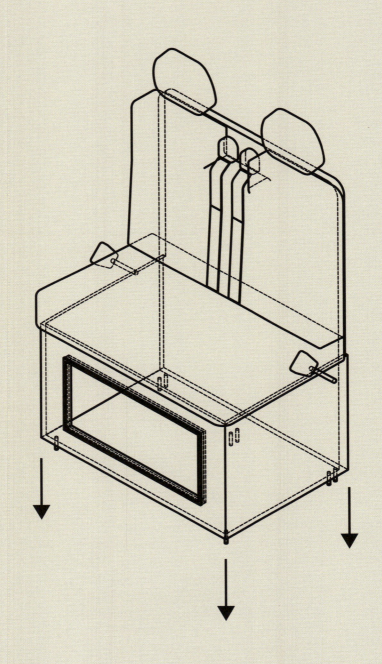

Any parts of your build that require secure fixing to the chassis, such as travelling seats or 'rock & roll' bed frames that we touched on in Part One, should be 'dry fitted' now. A travel seat will have a steel reinforced frame and a reinforcing bracket, a pressed steel plate, that sits underneath the chassis. This frame is bolted through the steel floor and the bracket. Depending on the make and model of the seat, you will need to select the correct fixings, length & diameter of securing bolts. Lift in the seat, decide on its final location in relation to your lining and furniture, and predrill the holes for the securing bolts. Avoid sitting the seats on subfloors, where there is a risk that 'voids' can be crushed when the seat is finally secured. Some models of bed frames and seats are designed to slide on rails or be removable. Consult the supplier for specific fitting advice. This is one area of your build where safety is extremely paramount.

When cutting or drilling the chassis or bodywork, take extra care to cover surrounding areas with plastic sheeting. Do not allow sparks, swarf or metal shavings to touch or settle on bodywork, windows or any part of your vehicle. This can cause rust and affect the paintwork.

Installing windows and vents

While we are on the subject of cutting holes in your expensive vehicle, now is the time to cut the biggest apertures of all! If you are ambitious and fitting an elevating or extended roof, you may need to cut away a large portion of the roof of your vehicle. Once this is complete, the roof kit will include a strengthening frame that will reinforce the portion that you have cut away.

For windows and vents, deciding on their exact location, marking out and preparing to cut are all extremely important steps. These apertures will be the biggest permanent changes made to your vehicle. Your choice of layout will inform the size, model and location of the windows and vents. I carry out most cuts from the outside of the vehicle, with the exception of bonded windows where the cut will follow the contour of the second steel skin.

The first step is to use masking tape and plastic sheeting to protect the surrounding areas, including the interior. Pay close attention to areas where cutting may fall between panels. Then mark out where you are going to cut either directly onto the steel using a fine-tipped permanent marker or onto masking tape using pencil. Use the 'swage lines' (the areas where panels are pressed to create lines or creases) and edges of the roof to align the holes, which are usually square with radiuses, with the vehicle. Windows should be fitted level with the vehicle. Here

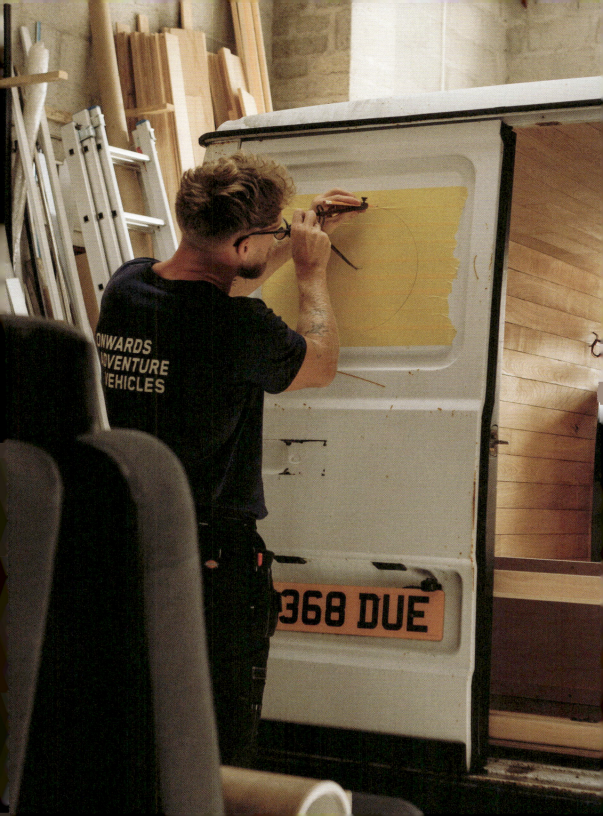

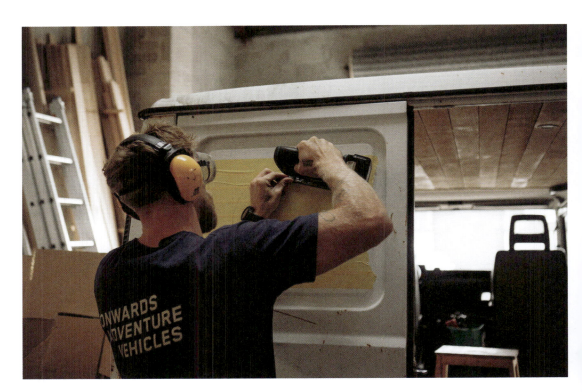
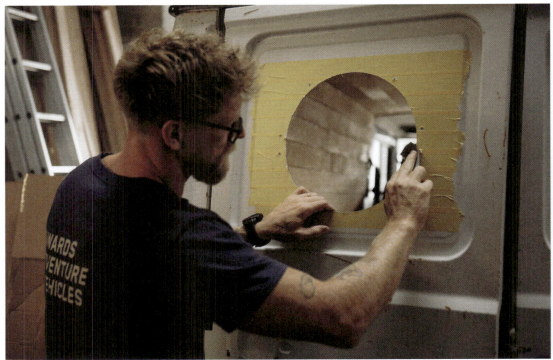

you will need to use your intuition to decide which datum to use as a level. For some makes and models, particularly those with exterior curves, you will need some time to consider how the windows function internally and look externally. A good practice is to level the windows with the internal load floor. This means that your windows will align perfectly with the tops of any worktops or furniture, once these units are fitted.

Once you are confident with the marking out, as a final check, drill a small hole in the centre of the panel and transfer the external measurements to the inside of the vehicle. This will allow you to check the window or vent is located where you had hoped, and that any internal fixings, cables or other hardware will not be caught while you are cutting. Depending on which tools you choose to cut the panel (air panel saw, nibbler, jigsaw, etc.) you will need to first drill 'access holes' through the panel to allow the cutting blades to pass through and start the cut. Use a drill and HSS drill bits to create these 'access holes', ideally 8-10mm in diameter. Locate the 'access holes' conveniently in the corners of the intended cut, as this will allow for the blade of your cutting tool to follow the corners easily, or for you to pause and adjust your handling of the tool to change direction.

Ensure you wear adequate safety goggles, eye and ear protection, and gloves. Do not allow the small pieces of metal created when cutting to get caught between your tool and the bodywork, as this will scratch the paint as you move the tool

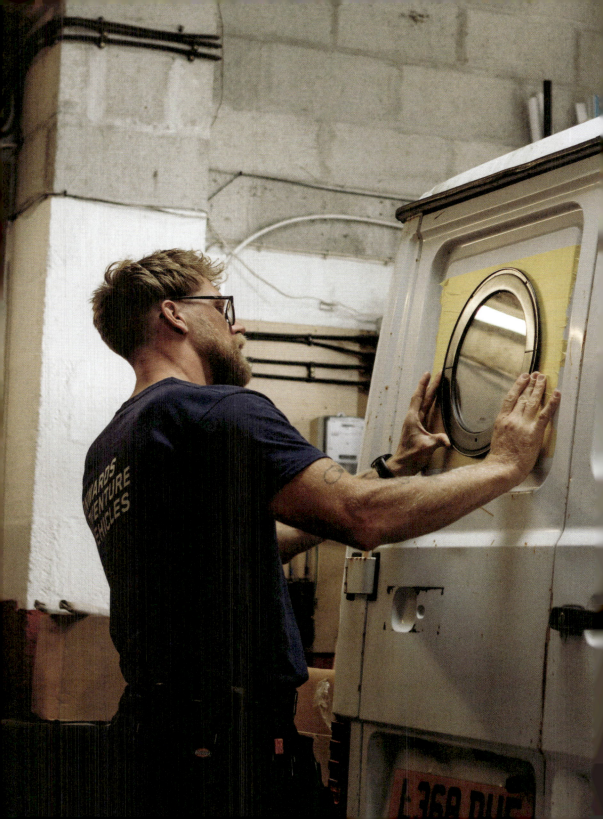

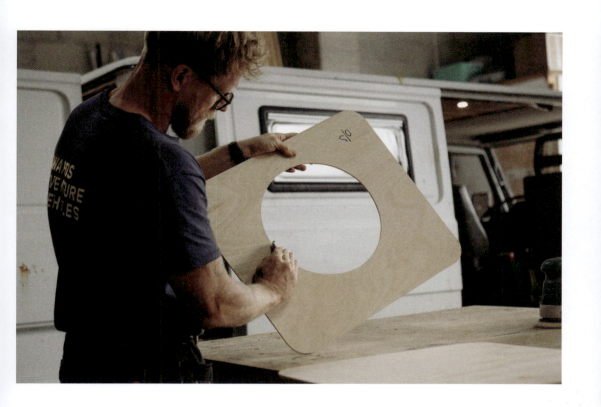

First dry fit of a porthole window, all is well. The interior panel is cut and sanded ready for lining and final fitting.

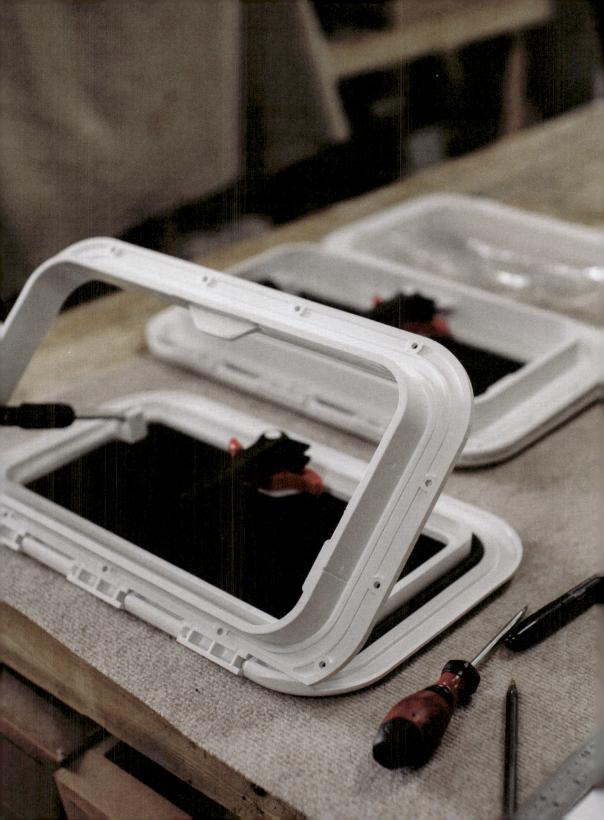

Vents cleaned and on the bench awaiting fitting. Tools prepared, deep breath.

MARK YOUR CUT LINE

RE-CHECK YOUR DIMENSIONS

ADJUST IF NECESSARY

ONLY BEGIN CUTTING WHEN YOU ARE CONFIDENT, THERE IS NO GOING BACK!

CUT HERE

along the cut. Make your movements slowly and deliberately and anticipate how the tool should be positioned when turning corners. A good practice is to cut inside your line, as a hole can be made bigger, but not smaller. Some vents and windows will also require the drilling of pilot holes through the single skin steel to allow for the fitting of screws. As with all holes, clean and prime the cut edges.

Once the holes are cut, dry fit the window or vent. Make any necessary adjustments to the hole so that the units fit snugly. Most windows and vents will require some form of packing, usually a timber frame to allow the unit to compress against the steel.

In most cases, it's best to use a PU adhesive sealant, such as Sikaflex, to bond the units to your vehicle. I prefer to add a bead of sealant to the channels in the window or vent and press it onto the vehicle. Apply a generous bead using a sealant gun and allow the sealant to ooze out of the joint. This acts as a visual cue that the surfaces are bonded. Then use white spirit, clean blue paper roll and silicon cleaning tools to remove the excess and create a uniform seal. These tools are designed to create 'fillets' by running the flexible edge along the sealant. I find they are great for removing excess. Each time you use a tool, clean it with paper roll and dip it in white spirit. This stops the sealant from sticking to the tool. Wear disposable gloves, and if they become contaminated, replace them with a clean pair immediately. This

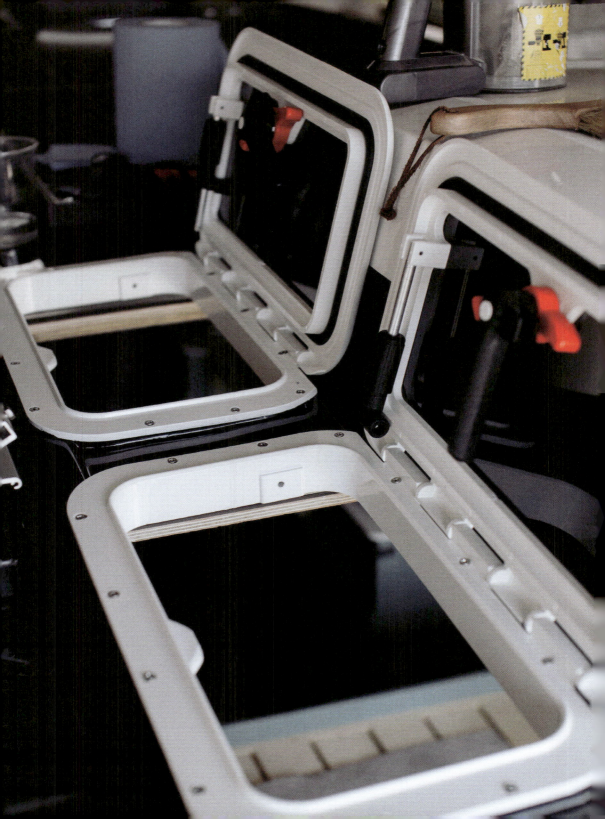

stops the transfer of sealant onto any tools or surfaces you may touch. Sikaflex in particular can be hard to clean off your hands and clothes. So take care!

Most issues that I encounter with self-builds are down to windows being fitted without the correct application of sealant, or the seal being left messy and unsightly. Again, this is down to not enough time and care being taken to clean the edges.

The bond and seal between vents, windows, inlets and the exterior surface is crucial. If compromised, water will enter the interior of your campervan.

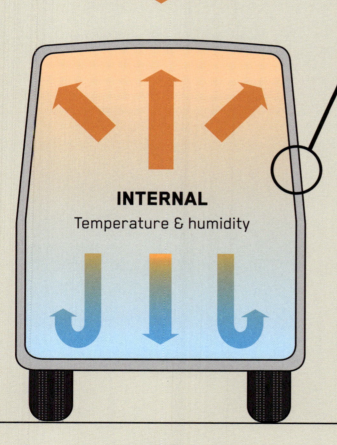

ADVICE
Condensation forms when warm air meets cold smooth surfaces.

HEAT FROM SUN

Cavity with insulation and trapped air reduces heat exchange.

INTERNAL
Temperature & humidity

COLD AIR

COLD TRANSFER FROM GROUND

Ventilation, lining and insulation

Cool when it's warm outside and warm when it's not: this is the purpose of insulating your campervan. Heat regulation is a hot topic (pun intended) not only in the context of a campervan but also our houses and buildings. Heat is energy. When lost unnecessarily, either via poor design or construction, we waste valuable resources and the effort taken to harness them.

There are two angles to approach this from: the conservation of energy and the overall comfort of the space. As hot air rises, due to it being less dense or not as 'heavy' as cold air, you will find that the lower sections of your habitation space get cooler. We can use this effect to allow for passive ventilation and the movement of this warm air up and out of the vehicle through vents: holes covered by hatches that can be opened, closed or fixed in different positions. Along with this warm air, fumes and smells from cooking and moist air from showers or sinks can be allowed to escape. We can assist this passive process by also adding forced ventilation. This is where the vents in the roof have built-in, powered fans that draw air in or out of the vehicle.

We add ventilation to the floor to allow cooler air to be drawn in as the warmer air exits. These vents also act as safety measures for any gas leaks (gas is denser than air) to exit the campervan through the floor.

When the outside temperature is lower than that which may be comfortable or safe, we need to 'trap' as much of the heat energy in the van as possible. This is made more of a challenge by the sliding doors, windows and materials that your vehicle is made of. Steel conducts thermal energy very well, as do glass and plastics. The cab area of your vehicle was designed by the manufacturer to provide comfort whatever the temperature: air conditioning when it's hot and blown-air heating when it's not. Yet the cab acts differently when the vehicle is stationary.

When we line our campervans with plywood or timber cladding, we create a void: a space between this lining and the outside metal skin of the vehicle. This is the space where we can add insulation to limit thermal transmission. Moisture carried in warm air will turn to condensation when it encounters colder surfaces, particularly smooth surfaces where the temperature difference is more dramatic. In order to mitigate this, the insulation void or cavity acts as a transition between the warmer inside air and the cold outside temperatures, or vice versa.

All materials intended for insulation are assigned an 'R' value. This refers to how efficiently they insulate thermal energy. Add to this the actual distance the heat must travel. This variable is dictated by the depth of the void that you have available. Typically this will be anywhere between 50 and 150 mm depending on the model of your base vehicle, and your approach to internal cladding. It is beneficial to know the 'R' value when purchasing

insulation materials, this value correlates roughly to the overall cost. The 'void' between internal cladding and outer steel skin will dictate what thickness of insulation you will use.

As most insulation materials rely on the air trapped inside them, it is a common misconception that compressing more insulation into a cavity will increase its effectiveness. In fact, the opposite is true so keep this in mind when filling your cavities with insulation.

Use recycled plastic fleece insulation, which is both effective and easy to handle. It also has the added benefit of being recycled, and therefore good for the environment. Avoid using rigid panel insulation or rock wool. These materials will either hold water, or are nasty to work with. Rigid insulation trapped behind panels can also cause annoying squeaks and noises as the vehicle moves.

All of the air that surrounds us contains moisture. We are familiar with condensation, drawing with our fingers on the inside of car windows. Moisture and porous materials do not mix. Moisture and metals do not mix. Oxidisation, rust and mould can be a disaster inside a campervan, particularly when hidden from view and given time to wreak havoc. Although there is a real fear that if condensation occurs it will start to rust your vehicle from the inside out, the actual long-term risk of this happening is very slim. I am yet to see a vehicle first-hand where this has happened.

ADVICE

Insulation materials can release fibres into the air whilst being handled, wear a mask! Do not be tempted to 'ram' in as much as possible - less is more.

HABITATION SYSTEMS

This part of the guide has been written to a level of detail that provides you with an understanding of the key elements required to design and build the power system in your campervan.

Note of caution: Electrical systems can be dangerous and even deadly if poorly designed and fitted. You must consult a professional if you are in any way unsure of the fundamentals and how to mitigate risk.

Electrical power

What does 'off grid' actually mean?

Key here is understanding that the 'grid' refers to the various utility networks that supply homes, business and public infrastructure. The trouble with a vehicle is that the opportunities to connect to this grid can be few and far between. The connections must be temporary and removable. When not connected, all power must be carried or generated.

Of all of the components that make up your habitation systems, some will be on display. The interface between you and the system can be beautiful in its own right.

What stored energy should I carry?

Chances are (unless you are reading this in the future, where EVs are the more prevalent choice of vehicle) your chosen base vehicle will contain an internal combustion engine that runs on liquid fuel, petrol or diesel. This liquid is stored in a large tank underneath the chassis. The chemical potential of this fuel, and the subsequent reaction caused by the ignition and rapid expansion of said fuel, is converted to kinetic power that then moves the wheels. There are subsystems connected to this engine, for cooling, lubrication of mechanical parts and charging of the starter battery via the alternator. As we design and build the habitation space and systems of the campervan, one key consideration is what other forms of stored energy we will include.

Ohm's law
Voltage = current x resistance

Voltage drop occurs between a load and a source of power (battery) where voltage is lost along the length of the cables due to resistance. Use an online calculator to check that your cable cross-section is safe, relevant to the length of cable you intend to use.

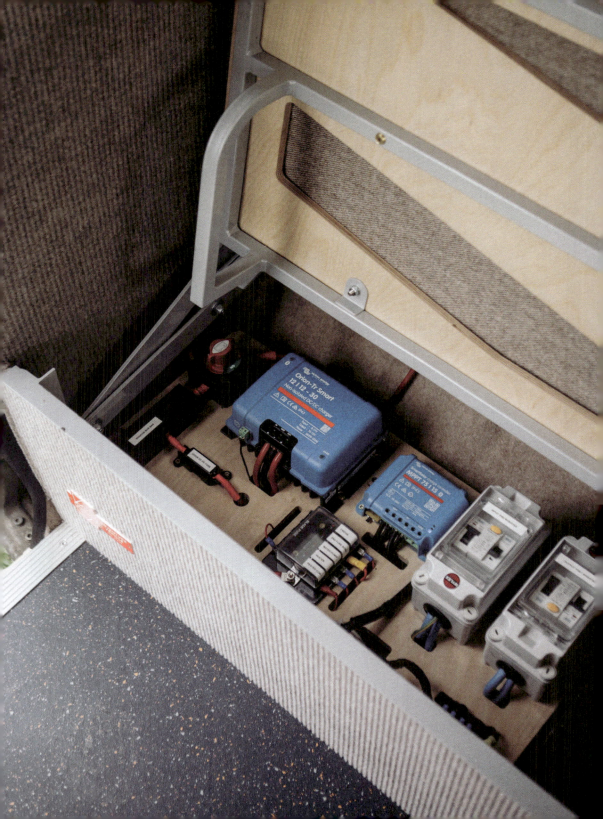

The first and most obvious is electrical power. Coming back to the starter battery, this unit stores 12V DC power in the form of chemical potential. The power is used by the vehicle to run anything from headlights to the onboard computer that controls the complex running of an engine. The caveat here is that your base vehicle may be an older model with fewer onboard electrics, but the process is the same.

To run most additional habitation systems in your campervan, we must provide extra sources of power: energy that can be created, converted, stored, transported and used. Firstly, we need to add a second battery or battery bank, one that is separate from the starter battery. This unit will allow for the storage of 12V (or 24V) DC power. As appliances inside your campervan use this power, it must be recharged at a rate that meets or exceeds the use. If power is used at a faster rate than the battery is recharged, the system will work at a 'deficit' and become fully discharged, which means no fridge or lights. Not much fun in the dark!

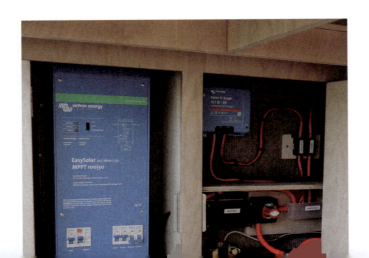

Accessing your system for general maintenance and fault finding is essential.

How much power will you use?

I spent hours as a teenager in physics classes learning all about circuits, resistance and the various formulae required to understand how electricity functions. Back then I had no real use for it. And only when I started designing and building these systems did that knowledge return from the deeper recesses of my mind. It can be a daunting subject, so let's start simply with how much power you will use. Again, create yourself a spreadsheet with the goal of adding up all of the appliances or 'loads' that you intend to include in your system. We will start with 12V DC – these will include lights, fridges, USB sockets, etc. Most campervans will also include domestic 240V sockets (more on these shortly). These may be added to power items such as laptop chargers, and if budget allows, larger appliances.

Once we have a total, in amp hours (ah) your system will consume, we will match this to the size of your battery bank (most battery capacities are displayed in amp hours – ah) and chargers are rated in amps and watts.

Amps = watts / voltage

EXAMPLE POWER USE

ah = amps x hours

Appliance	Power Watts	Current Amps	Use Per day
50L fridge	50w	4.2a	25.2ah
LED lights	12w	1a	4ah
Heater	36w	3a	24ah
Inverter	425w	35.4a	68ah
USB	12w	1a	1ah
Vent fan	48w	4a	8ah
		Total	130.2ah

This means that 130.2 amp hours of charge are required per 24 hours to sustain the system use.

Figures calculated at 12v

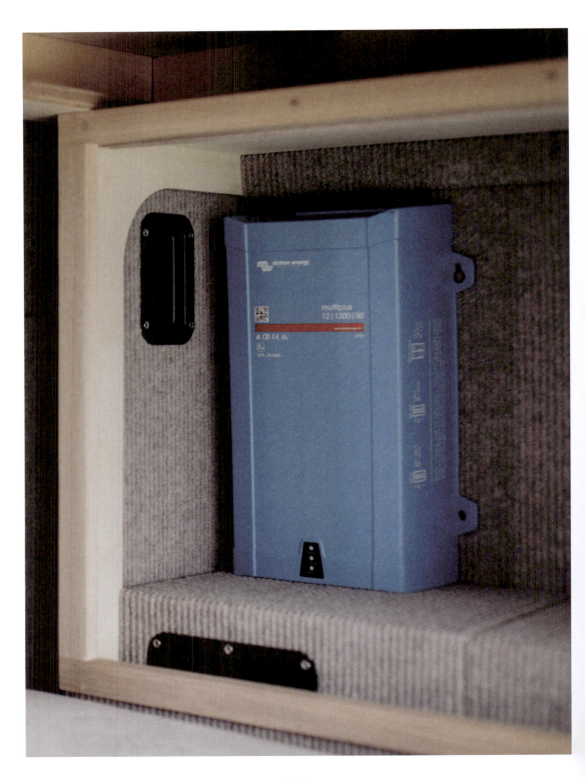

DC vs AC systems

DC, or direct current, refers to the flow of electricity. In a DC system, the energy flows in one direction. With AC systems, the current alternates the direction of its 'flow'. The rate of alternation creates a waveform and this is expressed in Hertz. Globally differing voltages are used, but in essence AC is used by domestic grids as transportation over large distances is easier.

The onboard systems in your vehicle will use 12V DC. If you were to locate a wire under your dashboard or in the engine bay and test it, chances are that it will read somewhere in the region of 12V. The power system that you will add to the habitation space will consist mostly of 12V DC, with the 240V AC (UK) part of the system being separate. The two systems can be joined via an 'inverter' that will allow you to turn 12V DC into 240V AC when off grid and provide power to domestic sockets.

When we want to use domestic appliances, chargers or high-powered equipment such as air conditioners in our campervan, we must integrate dedicated circuitry to carry 240V AC. Given the added risk of electrical shock with AC, there are extra safety considerations and local regulations that must be considered.

Coming back to the notion of 'off grid' and 'on grid': If you park your campervan at a campsite that has the capacity for 'hook-up', this means you can plug your vehicle habitation system into

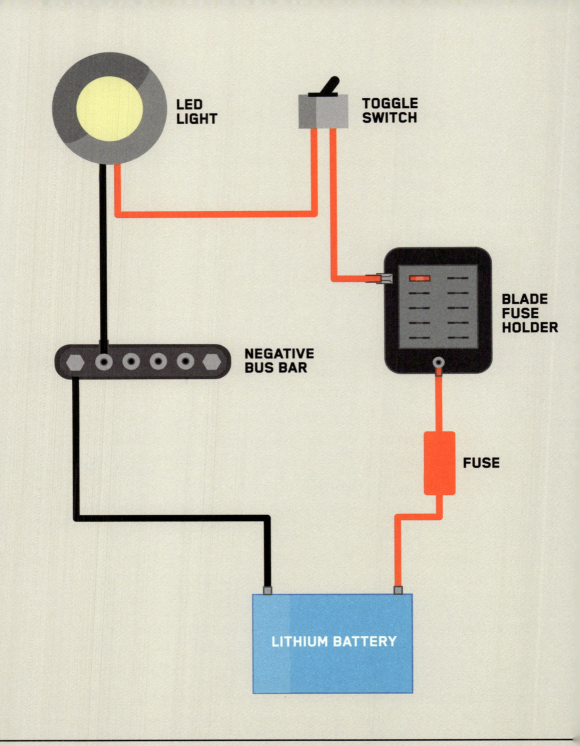

the grid via an extension cable. The simplest arrangement is to take the 240V AC and directly supply appliances and sockets with this power. In effect this forms an extension of the grid supply that enters your vehicle via an inlet, with the wiring connected via onboard safety measures. This would include trip switches that sense a fault and turn off the supply.

Safety and key considerations
Fusing of wires: the weakest link concept

The purpose of fuses and trip switches is to allow for the 'breaking' of a circuit if a fault with the load or source of power occurs. There are many types of fuse, from 1 amp blade fuses to 500 amp and mega fuses. The selection of a fuse is informed by the maximum current that a circuit is designed to carry. This is usually based on the draw of the load that the circuit is supplying. The fuse will 'blow' if this maximum current is reached and/ or exceeded. The wire of the circuit should always be rated to higher than this maximum current rating, allowing the fuse to blow before the wiring heats up. This can be dangerous as wire that is forced to carry a higher current than it is designed to will heat up and become a source of ignition – aka fire. I cannot stress enough how dangerous this can prove, particularly in the context of a small space that is filled with combustible material and other fuel sources.

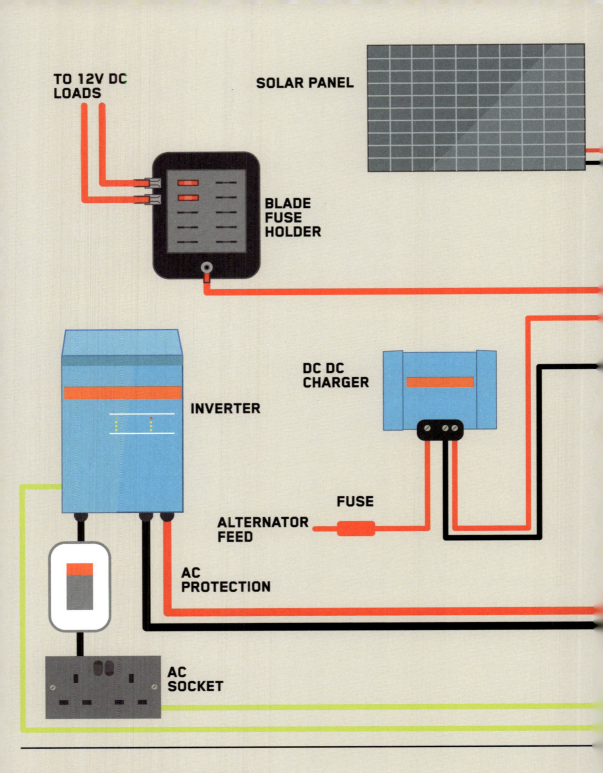

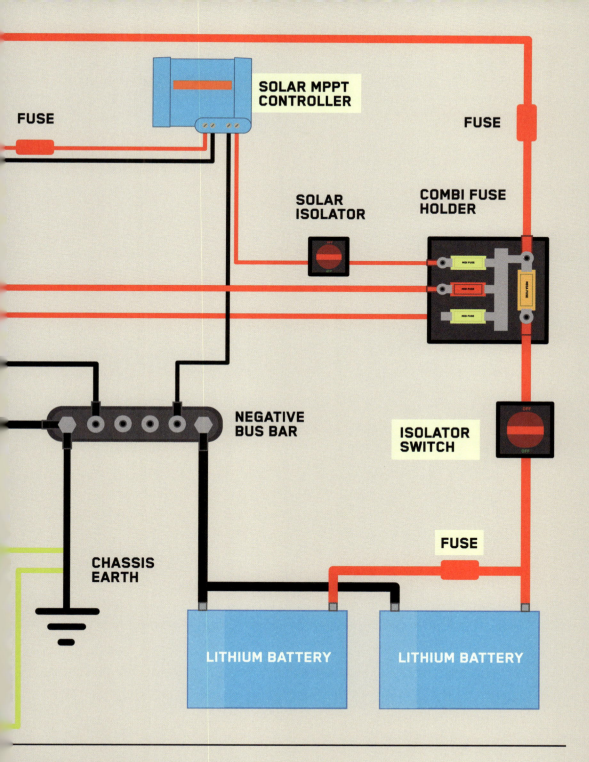

Cross-section and length of wires

Cable or wires are rated by their cross-section, which in the UK is expressed in mm². The cross-section links to how many nominal amps (current) the wire can safely carry. Match the cross-section of your chosen wires to the load that it will supply. For instance, a 12V DC LED light that will draw 3 amps to run should be matched to a relevant cross-section of wire. In this case, 1 mm². The second reason for matching wires to single or multiple loads (if supplying fuse boards, etc.) is the cost. Copper is expensive and you do not want to use an unnecessary amount in your system.

Ohm's law
Voltage = current x resistance

Voltage drop occurs between a load and a source of power (battery) where voltage is lost along the length of the cable due to resistance. Use an online calculator to check that your cable cross-section is safe, relevant to the length of cable you intend to use.

Common ground

Your 12V DC system will consist of two separate poles: positive and negative. Vehicle manufacturers use the chassis of the vehicle, which conducts due to its steel construction, to carry the negative pole in the form of a common ground. You can also build your system to use this.

Protection for wires and cables

When routing cables behind panels, take care to protect them from wear and chafe. We have mentioned the benefits of conduits when explaining the 'first fix'. Anywhere that wires may encounter vibration or movement, such as those that are located underneath the vehicle or inside panels, use anti-rubbing tape and flexible conduits for extra protection. If the outer plastic sheath is compromised, faults in the system and 'shorts' can occur.

Connections and access

As your system connects many different pieces of equipment together, you will need to cut wires to length, trim off the plastic insulation and crimp on a variety of connectors. Crimping tools can be hand operated or battery powered. The tools will have positions that match specific crimp sizes or have interchangeable guides to match larger cross-section cables. Smaller connectors for wires between 1 and 6 mm² will use spade or hoop connectors. For larger cables that supply batteries, inverters and chargers, you should use 'bare lugs' that match the stud size of the connectors. For instance, most lithium battery terminals are an 8 mm stud. Depending on your system, you may connect a 35 mm² cable to this terminal with a lug rated to that cable cross-section and stud size. These bare lugs or crimps should be covered with heat shrink to ensure a secure and safe connection.

A 200ah lithium battery bank mounted alongside a inverter charger unit in the garage space of a campervan.

Batteries and chargers

For simplicity, we will focus on lithium batteries to power your system. Older systems in motorhomes or campervans may use lead-acid or AGM batteries as the base for power storage. We are now moving away from these types of batteries due to their storage and use constraints. A 100ah lithium battery will supply a 1 amp load for 100 hours, or a 100 amp load for 1 hour.

As these batteries are sensitive to heat, low temperatures and excess charging or loads, these must be connected to the system via a battery management system (BMS). This piece of equipment controls the charge in and out of the battery and monitors the internal temperature.

Charging sources are via your alternator when driving or while the engine is running, via solar, or via a mains charger when on hook-up. A DC DC charger will take the excess power generated by your alternator and charge the battery bank. Any charger in the system should be linked to the BMS via Bluetooth or data cables to ensure safe and optimum charging.

A mains trickle charger will allow a 240V AC campsite hook-up to charge the 12V DC battery bank and is usually incorporated into a single unit with your inverter and a transfer switch. This switch senses when a campsite mains hook-up is connected and turns off the inverter to save power.

A porthole window being fitted.

A habitation system mid build. You can see the combi heater, inverter charger, and access to the shower plumbing.

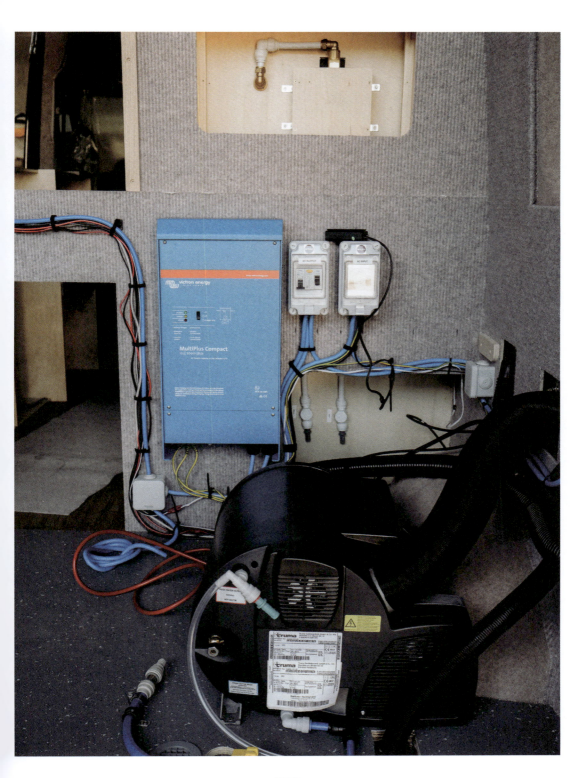

Solar energy

I would love to change the name of solar panels to 'sun traps' or 'daytime energy cells', which are far more exciting. Solar panels are ingenious inventions that can adorn any flat surface where the light from the sun falls. They contain crystals that, when exposed to sunlight, produce electricity. Having fitted my first 100w solar panel to the roof of my van, I sensed real magic when I then took a cold beer out of the fridge.

However, the constraints to consider with solar are:

Usable roof space

When deciding on the extent and location of roof vents, research the available sizes of solar panels, and the required total area. The panels should be located so that they don't impede the operation of the vents. The panels also need to be free from any type of shading. You may opt to mount the panels directly to the roof using aluminium brackets, or onto a roof rack. Some panels are designed to be walked on, while others are covered with fragile glass sheets.

Budget

Although relatively inexpensive per 100w, consider your overall budget and how much you can allow for your total solar set-up.

How much yield you require

This will be dictated by your total power usage. Consider that a 100w panel will in fact rarely yield that amount. For example, in the UK a solar panel will produce anywhere between 30 and 80% of its stated yield depending on cloud cover and the angle of the sun. Usually the solar array will be designed to yield as much power as your roof space will allow. However, on rare occasions where a power system is simple and the usage is low, excessive solar yield cannot be used.

Once the panels are arranged and fitted, a solar MPPT controller will be needed. This will regulate the charge from the panels and feed this into the battery bank.

LPG gas

This onboard fuel source can be used for heating and cooking. Most campervan hobs and ovens run on gas and even some combi heaters that heat air and water. Traditionally, a refillable gas bottle would be stored in a locker and removed and replaced when empty. A regulator is fitted to the gas bottle and gas is supplied to appliances via rigid copper pipework. We also fit under-chassis LPG systems that consist of a tank permanently fixed to the underside of the vehicle that can be refilled via an inlet on the side of the vehicle. The added benefit is that the gas is contained outside of the vehicle and can be refilled cheaper than a replacement bottle.

There are several safety regulations to consider as gas, particularly in a confined space, can be deadly. Manual or automatic shut-off valves for each appliance should be fitted. Adequate ventilation is key, both while running hobs and cookers and in case of a fault or leak occurring. Consult a trained gas engineer when fitting any type of gas system, and regularly check any existing system for leaks.

A stainless steel hob unit with sink cover in place. Be mindful of how gas systems operate, where heat may interact with combustible materials. Fit heat shields where necessary.

Diesel

As with gas, diesel can be used for heating and cooking. Diesel is most often used to heat campervans via a blown-air heater. These small and highly efficient heaters can be mounted inside or outside the vehicle (to the chassis) and are usually plumbed into the vehicle's main fuel tank, meaning that a separate fuel source is not required. These heaters use a small amount of diesel to efficiently heat a campervan interior. As they produce exhaust fumes when operating, they are designed with separate air intake and exhaust outlets. They are popular in both the automotive and marine industries.

We are also seeing manufacturers offer 'combi' heaters, those that heat both air for the living space and water, in diesel-fuelled models. These supersede the older LPG models due to the increased versatility. LPG gas refilling stations are more difficult to locate than standard fuel stations and diesel fuel performs better at lower temperatures than gas.

A ceramic top diesel hob unit. These cooking appliances are plumbed into the main vehicle fuel tank and remove the need to fit a gas system to your build.

SELFBUILD CASE STUDY 03

+ some inspiration

Name: Tom Guilmard

Number of campervans converted: 1

Campervan make & model: Suzuki Super Carry 1,883 mm height, 2,110 mm wheelbase

Converted by: Myself with some much needed technical guidance from a close friend via phone calls and FaceTime. I planned the layout and my ex-partner dealt with the curtains, upholstery, etc.

Used for: Trips ranging from a couple of nights to a month. Key conversion factors: Interior design of the campervan. Advice: Do it. Take your time, enjoy the process and don't be discouraged by how long the first part takes. Once your foundations are in place, the rest of the build comes together relatively quickly and it is extremely exciting to see. Whether you use your van all the time or just occasionally, having access to a camper will only improve your experience of life. Having built it yourself only improves that experience.

This was my first campervan conversion, and it was somewhat ambitious but still within my skill set. At the time, I wasn't very well or doing much with my life. I couldn't tell you why I started doing it – there was no reason or motive but it felt like the only thing I could find the energy to do. Progress was slow and it

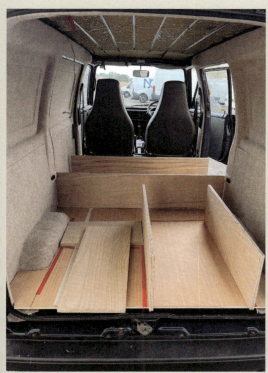

took a lot longer that it should have. I found it useful for my illness to work with my hands.

Because of the size of the campervan, using the space was key. The whole cab is a bed on a 'false floor' with storage underneath – there's a small cabinet at the rear right of the cab for grabbing essentials, and the 'kitchen' pulls out of the back, the hatchback providing shelter when cooking. The back of the bed doubles up as the counter for food prep. We also had to use a roof box mainly to store chairs and my art supplies. There was a lot of crossover between the use of areas.

Habitation Systems
Under the 'false floor' are compartments for clothes storage that are accessed from each side of the bed. There is one leisure battery that supplies power to a light with two USB chargers. All other lights are powered by household batteries. The cooker uses small gas canisters on a portable camping stove that has a semi-permanent home.

Likes
I enjoy the whole thing – I'm constantly shocked by how functional the layout I designed is. It feels like a completely happy accident and in this regard I wouldn't change a thing. I love it when the van is ready for the evening and the cab is a full bed that feels spacious and cosy at the same time.

Dislikes
The biggest improvement would be to the 'kitchen' area. Although it works fine, there is scope to create a more functional and sturdy pull-out kitchen using load-bearing brackets and legs. I would also like to find a more convenient refrigeration solution as our cool box, although good, is too big and requires shuffling the back around when on the road.

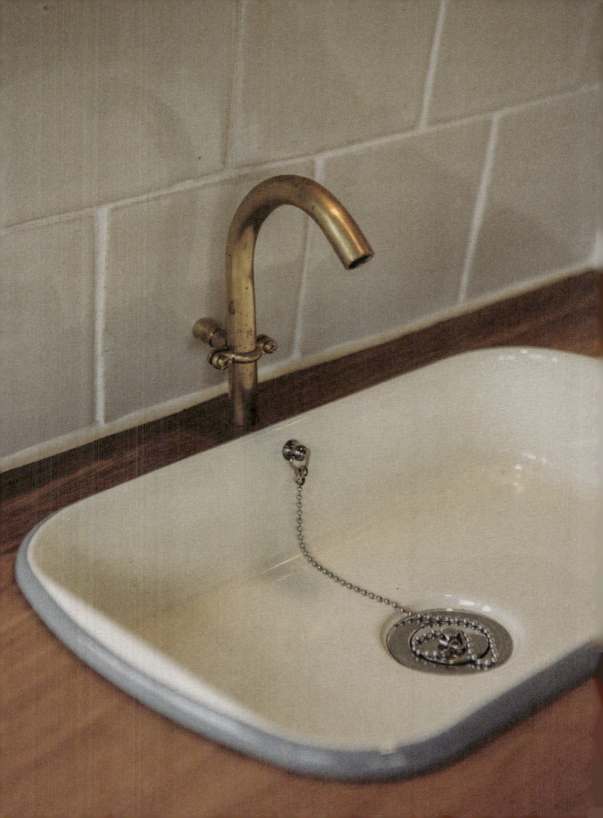

WATER AND PLUMBING

The ways in which you can store, transport and use water in a campervan are vast and varied. As with all systems, they can be designed with many branches, connections, valves, adapters and storage tanks. Water for drinking, water for washing, water for waste. Liquids have a tendency to fill any container or space without abandon, sometimes to our detriment. Therefore, we must contain, transport, use and dispose of water. We must also be mindful of how to contain leaks and isolate areas of the system if one occurs.

The elephant in the campervan plumbing room is of course the amount of water you can carry. We touched on this previously but be realistic about your system and its water capacity. Even short showers can use a surprising amount of water; some up to 12 litres of water per minute!

Using isolators at each branch of your system will allow you to close off those parts if a leak occurs. It also avoids having to drain the whole system if you need to service that part. Most tanks, pumps and pipework (rigid or flexible) are made from plastic. Ensure you check that the parts you intend to use for your system are 'food safe'. For connections in flexible pipework, use high-quality marine fixings and stainless steel Jubilee clips.

Tanks

The containers for your drinking and waste or 'grey' water can be mounted inside or underneath your campervan. The benefit of mounting them inside is that they are generally easier to secure in place and service, plus they benefit from being heated by the ambient inside temperature when the weather outside is cold (reducing the chances of the contents freezing). The downside is that they take up valuable space, and if they fail the contents will empty into your campervan.

Under-chassis-mounted tanks are the second option. These are usually mounted using steel or aluminium brackets. They are subject to the movements of the vehicle and elements while driving. They must be protected from cold temperatures by insulation and heated probes or mats to stop the contents from freezing.

Consider how the filler pipes, usually a 40 mm flexible hose, will be mounted. These may need to be routed through the floor of your campervan and down into the tanks. The tanks will also need to have drains, allowing them to be emptied, and breathers to allow the air inside to escape as they are filled.

The tanks can be made from plastic, aluminium or stainless steel, with plastic being the more affordable option. Popular base

vehicle models will have specific tanks available. These have been designed to fit snugly around the chassis structure, optimising space and capacity.

ADVICE
Use stainless steel marine
grade jubilee clips.

**MICRO SWITCHED
TAP**

SINK

**12V DC
POSITIVE**

WASTE PIPE

**12V DC
NEGATIVE**

WATER TANK

TO GREY WATER TANK

**SUBMERSIBLE
PUMP**

Submersible pump system

This set-up involves a small pump that is, as the name suggests, submersed in a tank, usually through the filler neck of a removable plastic 'jerrycan'. A microswitch in the tap, or a separate switch, turns on the pump and water is drawn up and out of the tap.

Use this method if you are looking for a simple, affordable system. There are many different brands and designs of submersible pumps, and replacements can be bought easily.

The wiring is a simple single-loop circuit that can be incorporated into a simple 12V set-up. Remember to check the amps that the pump will draw when creating the circuit and be mindful not to run it for prolonged periods when 'dry', as this can shorten the life of the internal motor.

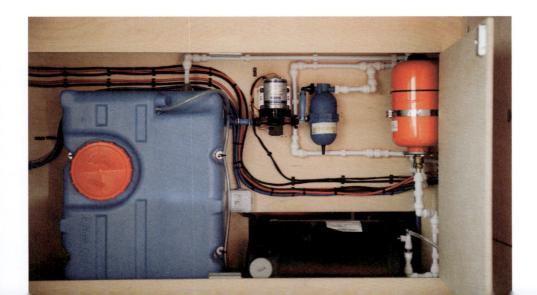

ADVICE

Plan ahead for how the water will drain from sinks and showers. Add 'traps' to stop foul odours from returning from the grey water tanks.

DOMESTIC TAP

SINK OR SHOWER TRAY

WASTE PIPE

FLEXIBLE OR RIGID PIPEWORK

TANK BREATHER

TANK DRAIN TAP

GREY WATER TANK

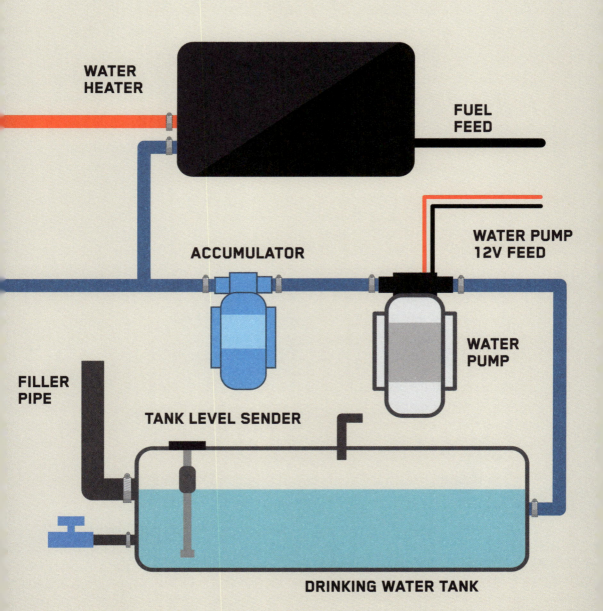

Pressure-activated pump system

For larger plumbing systems that branch off to supply multiple outlets (taps and showers), use a pressure-activated pump. These 'closed' systems rely on the opening of an outlet for the system to activate. As the pressure drops, the pump turns on and forces water through the tap. When closed, the pressure builds and turns the pump off. This is the equivalent of turning a domestic tap on and water being readily available. The system stays pressurised and can therefore be prone to leaks if joints and connections are not checked and adequately tightened.

Pipework and connections

Once you have decided on your water system, consider how your pipework will route through your campervan interior. Will the pipes, connections and isolators be easily accessible in the future, even with luggage and items in drawers and cupboards? Pipework should be neatly routed and securely fixed in place using pipe clips. Avoid high spots and loops where air can become trapped.

If your system incorporates a water heater, be aware that as the hot water expands, your system must be able to accommodate the additional pressure. An expansion tank can be added to larger

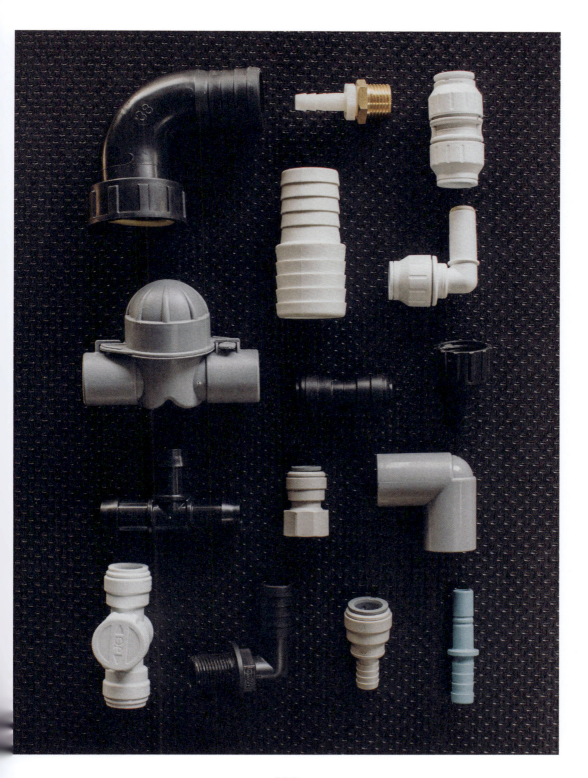

systems to deal with this. Heaters usually include an emergency drain and pressure relief valve. These will need to be routed through the floor to the underside of your vehicle.

Filling and filtration

Water contamination from bacteria, microplastics and other organic matter is becoming a real concern, with growing evidence that even some domestic supplies are harming our health. For peace of mind, we can add in extra filtration to remove as much of these as possible. There are various ways to filter water: matrix, reverse osmosis, UV light exposure, to name a few. Most are designed with a housing and replaceable filter and rely on the pressure of the system to force water through the membranes in the filter. Remember to allow room to access your filters and replace them.

Filling of your water tanks is performed by placing a hose through a filler inlet on the side of your campervan. These filler inlets are available in a range of designs, most with lockable caps. They are mounted by cutting an aperture in the side of your vehicle and bonding and/or screwing the inlet to the steel surface. Follow the same procedure as fitting vents and windows.

When choosing where to fit your inlet, check that it will not be covered or hit by opening doors, particularly sliding side doors.

Optimise its position in relation to your internal layout and furniture. A 40 mm flexible filler hose will be fitted to the hose barb on the inside of the inlet. Use a stainless steel Jubilee clip to secure this in place and route the filler hose to your tanks. Remember that the filler inlet should be mounted higher than the tank to make filling easy.

Cleaning and maintenance

Avoid storing water in your tanks when your campervan is not in use. Standing water will become a breeding ground for bacteria and algae, which will contaminate the tanks and the plumbing. Drain the tanks regularly and only fill the drinking water tanks from domestic sources. Tank-cleaning additives are available, but always follow the instructions and flush the system to avoid contamination. Before filling your tanks and system after a hiatus, perform a visual check of all pipework and connections to confirm there are no leaks. Finally, it is always good practice to turn off pumps when you exit the vehicle. This avoids a leak allowing the pump to empty the tank into your campervan interior.

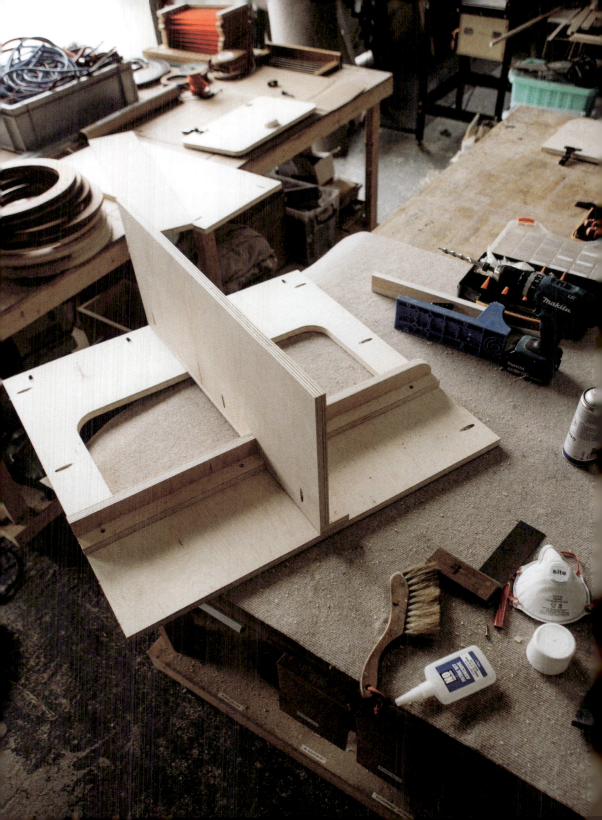

FURNITURE

The first campervan furniture I ever built was basic lengths of softwood batten, screwed and glued together to create a simple framework. I fitted softwood cladding, some cupboard fronts, a worktop made from an old IKEA desk and covered it all in a layer of boiled linseed oil. I was proud of my achievement, and it served us extremely well. No complex joints, master carpentry or CNC machine (a computer controller router) in sight! It is so easy to overcomplicate furniture.

Once fitted, the furniture of your campervan will transform the space, making this one of the best moments of the build. Some of the separate units can be built outside of the van, but others may need to be constructed in situ. This will depend on how you choose to build the furniture.

The building blocks of your campervan interior start to come together.

As the units are fixed inside a moving vehicle, they should be constructed using methods that ensure strength and rigidity of the joints. The vibrations from driving can cause screws and bolts to loosen over time. By including mechanical joints and adhesives, we can achieve a solid structure that does not move. Some materials, such as timbers, will also be affected by the changing moisture content of the ambient air. You may find that, when the air is dry and warm, a cupboard drawer may shift and catch on the frame. Mitigate this by allowing for the right tolerances between moving parts. The main considerations for your furniture are weight, fit, materials, carpentry and joinery, hardware and finish, as well as allowances for systems.

Weight

You should refer back to your weight projection table and check that each element is in line with your calculation. If the unit cannot be adapted at this stage, you will need to look at other areas where you can save weight.

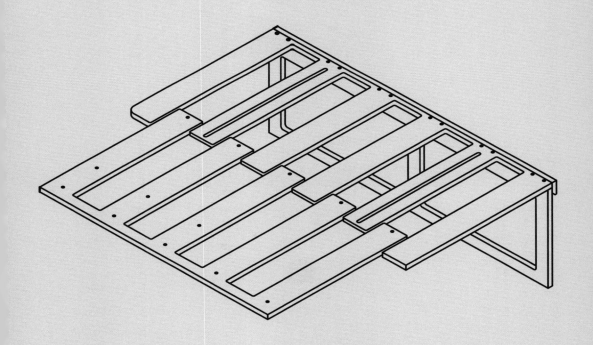

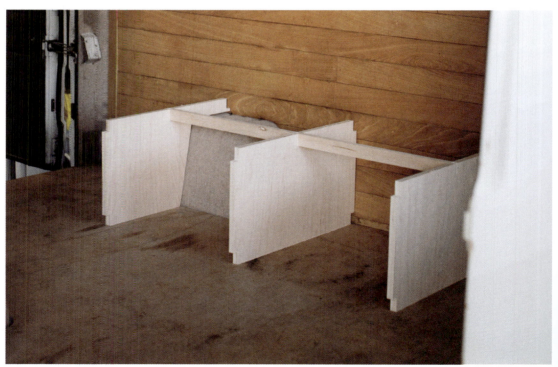

Fit

In theory, all of the furniture you will build is 'flat-pack': you will take flat materials (lengths of timber and panels) and bring them together into a 3D structure. When you first sketch out your furniture (on paper or using CAD software) start with simple blocks – rectangles that make up the kitchen, seating and bed area. Then refine these blocks to include more complex forms, drawers, cupboards and lift-up/out sections for access to storage areas and systems. These separate 'units' will need to fit snugly together and against the lining of the walls, floor and ceiling.

In order to achieve a good fit, carefully measure the contours of your base vehicle interior. This can be done by measuring bends and curves at regular intervals (say every 20 mm) and transferring these into your designs as a grid. You can also use cardboard or scrap pieces of plywood to create templates. A handy trick is to use a hot glue gun to piece together scrap timber around curves and use this as a basis for a template.

The basic structure of a a pull-out bed section is dry fitted inside the vehicle. Final fit against the walls and floor are checked and adjusted if needed.

Materials

Timbers are categorised as 'softwoods' and 'hardwoods'. Softwoods are fast growing and less dense and include timbers such as pine. They are lightweight and cheaper than hardwoods, and better suited to general joinery, framing and trims. Softwoods are also easier to work with, requiring less effort to cut and shape than hardwoods. Hardwoods are slower growing and usually more dense and thus heavier than softwoods. As the name suggests, their 'hard' nature means they will blunt blades and cutting edges of drill bits quicker than softwoods. They are generally more expensive and sought-after for their more complex grain patterns, colours and textures. Some hardwoods such as teak and iroko are better suited to wet environments due to their high natural oil content and resistance to rot.

Consider using cheaper softwoods in areas that will be covered by panel materials and/or hardwood trims. This will allow you to achieve a premium finish while reducing cost and weight.

The main panel material to consider is plywood. It is a versatile product that is available in a variety of options. The panels are made up of layers of timbers sandwiched with adhesives that are 'laminated' using heat and pressure. These uniform panels can be cut and sanded easily. Plywood is rated by its quality, with outside faces containing imperfections being rated lower than panels

manufactured with faces specifically for final 'joinery' purposes. These premium panels may even have faces made from laminates of other timbers such as birch, maple, oak or ash. Lightweight plywoods with cores made from poplar or similar timbers are ideal for use in campervan furniture construction thanks to their lightweight nature and usability. Plywood can be protected further by adding exterior laminates made from composite materials or other finishes.

MATERIAL	TYPE & SIZES	USE
HARDWOOD PLYWOOD	Standard panel 2440mm x 1220mm 9, 12, 18, 24mm	First fix, subfloors and ply lining
POPLAR PLYWOOD	Standard panel 2440mm x 1220mm 9, 12, 18, 24mm	Furniture structur and framing
BIRCH PLYWOOD	Standard panel 2440mm x 1220mm 9, 12, 18, 24mm	Furniture finishing worktops, tables a structure
PINE	Softwood Various sizes Rough sorn & PAR	First fix battens ar structure. Furnitu framing
ASH	Hardwood Various sizes Rough sorn & PAR	Joinery, final fix cladding, worktop and trim
IROKO	Hardwood Various sizes Rough sorn & PAR	Joinery, flooring worktops, tables a trim
OAK	Hardwood Various sizes Rough sorn & PAR	Joinery, final fix cladding, worktop and trim

WEIGHT & DENSITY	COST & AVAILABILITY	NOTES
Medium weight and density	Widely available and low cost	Takes fixings well. Prone to splintering on edges
Lightweight, low density	Available from industry suppliers	Specialised product manufactured to be lightweight
Medium to heavy weight, high density	Widely available , medium to high cost	Widely used in contemporary furniture
Lightweight, low density	Widely available , low cost	The lowest cost option for cladding and furniture
Medium to heavy weight, high density	Widely available , medium to high cost	Our timber of choice for joinery and ceiling cladding
Medium to heavy weight, high density	Available from industry suppliers, high cost	Oil content makes it perfect for high moisture environments
Medium to heavy weight, high density	Widely available , medium to high cost	A heavy timber that looks beautiful when finished

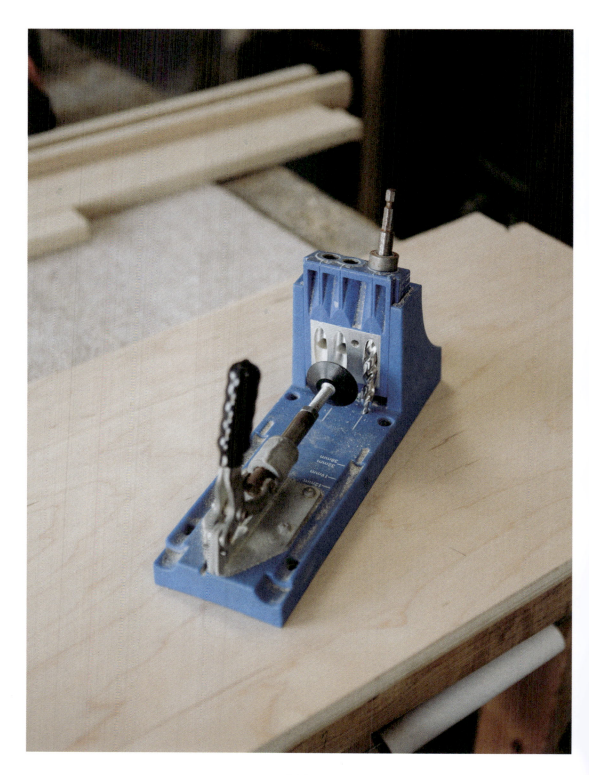

Carpentry and joinery

The fundamentals of carpentry are accurate measuring and cutting. If you can mark a piece of timber, cut it accurately, and prepare it for jointing to another piece, you can create high-quality furniture very easily. Most errors come from failure of the above. Basic joints such as a butt joint, where the end grain of a piece of plywood of timber meets the side or face of another, are the easiest to perfect. They can be made more complex by introducing pockets, slots or dados for the end grain to sit into. Or fingers, dove tails or all manner of mechanical joints that rely less on fixings and glue and more on a tight mechanical fit.

Pocket holes are a fantastic way to construct campervan furniture. A jig is used to cut a screw hole at a shallow angle into the face of a board or piece of timber. This allows the butt of the piece to be securely fixed to another face. With the use of wood glues, these joints are quick and neat.

When fixing separate pieces of plywood or timber together, use clamps to secure the construction. Consider how screws will split the timber when used close to the edges of a material. Use pilot holes, small holes drilled to allow for the screw to expand the surrounding timber and not create unnecessary pressure, resulting in splits and checks.

An adjustable pocket hole jig is a quick and easy tool to use. A preferred method of creating butt joints in panel and plank materials.

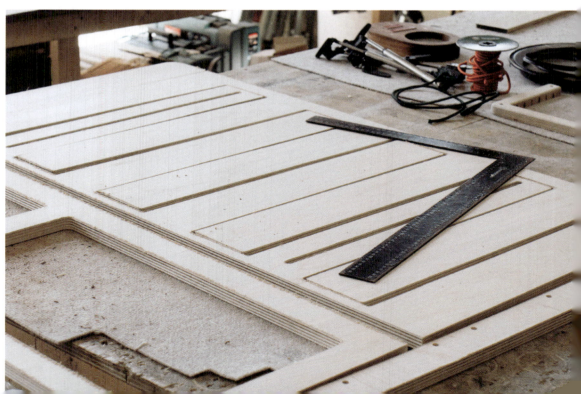

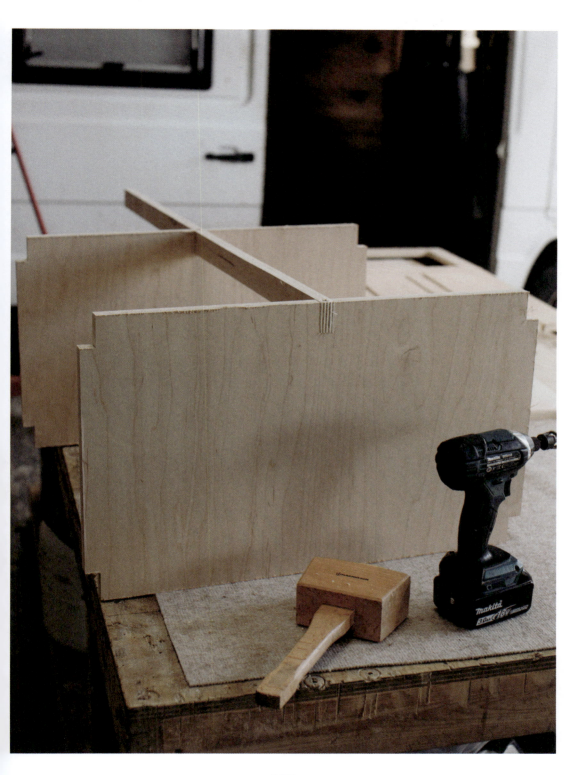

Once your units are constructed, you will need to dry fit them into your campervan. This is your chance to make any adjustments. Once you are happy with the final fit, secure the units to the plywood subfloor and plywood or timber lining using L brackets and/or pocket screws. You should also secure each unit to the one that sits next to it. In the event of a crash, the units must be secure enough to avoid them coming loose and flying forwards into the cab area, potentially causing harm to the driver and passengers.

Hardware

Once your units are constructed, you will add drawers and cupboard doors by fixing movable joints such as runners, hinges and latches. Latches, handles and some hinges will be seen from the outside, and your choice of these will be dictated by the aesthetics of your campervan interior. Hinges and runners will be subject to regular movement so avoid budget versions that will fail over time and need to be replaced.

Hinges that allow for adjustment, like those used in domestic kitchen units, will help when aligning cupboard doors. More traditional hardware, including solid brass or stainless steel butt hinges, will require a greater level of accuracy to mark out and fix doors.

Latches are important in a campervan. You do not want the contents of your cupboards and drawers flying out as you turn a corner or hit the brakes unexpectedly. Consider mechanical latches over magnets that securely lock a door or cupboard in place, usually in a 'push' design with a positive action that confirms the latch is engaged.

Finishing

Once your furniture is constructed, you will need to protect it against use and the elements. Even inside your campervan, surfaces will be subject to spills, stains, dirt and moisture. Even the natural oils on our hands will transfer to surfaces that we touch regularly. Natural timbers can be sealed using oils, stains and varnishes. If you opt for a painted finish, choose paints that are steadfast against regular use.

Before applying finishes, ensure that timbers are prepared. Remove any marks left from cutting blades using sandpaper. In general, a high finish can be achieved by working through grades of sandpaper to achieve a smooth and even surface. Start with a coarse grade such as 80 grit to remove any deep scratches or marks. Change this for a 120 grit, and finally a 240 grit paper. If you are using finishes that require sanding between coats, use a 240 grit paper to flatten back the finish before applying the next coat.

Oils are a budget-friendly option for timbers. They penetrate the wood structure and repel moisture and dirt. These will often change the colour of the material and darken further over time. Timber treated with oils should have a layer reapplied once every couple of months to ensure renewed protection.

There are a wide variety of natural wood oil treatments available, some containing little-to-no VOCs (volatile organic compounds) that are emitted by most paints and solvent-based varnishes and lacquers during their drying phase. Be especially mindful of this within the compact interior of your campervan.

Paints, varnishes and lacquers create a hard protective layer on the surface of the material. These will require adequate preparation, drying times and sanding between coats to achieve a high finish.

Here a natural oil is applied to maple faced plywood. It saturates the wood and the excess is removed with a dry cloth. Run the cloth in line with the wood grain for a smooth even finish.

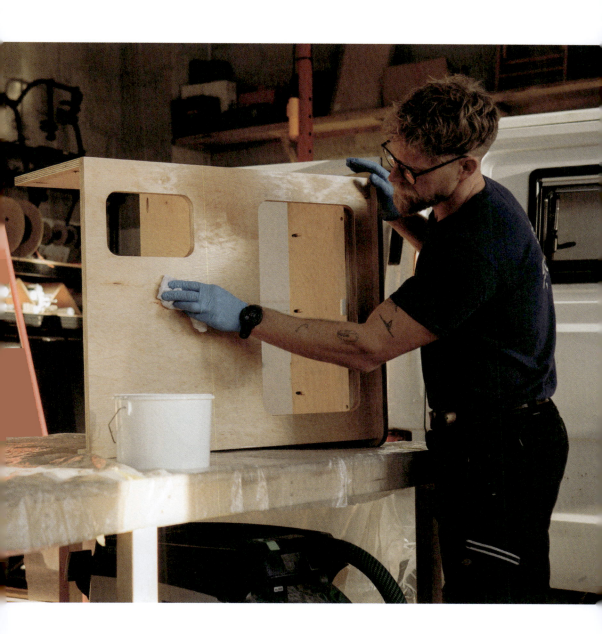

The first few miles on roads in a finished campervan are exciting and nervous. You will slowly get used to the sounds, you are sure to identify a few that need addressing.

Final touches and trial runs

Now your interior is complete, and your systems are up and running, take this chance to make your campervan a real rolling home. Add the upholstery to the seats and mattresses to the beds. Blinds or curtains can also be fixed in place and trialled. Smaller storage solutions such as pockets and pouches can be fixed to walls. We like to add small leather loops for mugs and anti-slip mats to shelves, cupboards and drawers before packing the van with items and luggage. Exterior parts such as awnings, bike racks and roof racks can be fitted (remember some of these will require fixings to be added before your lining goes in). Fill the water tanks, turn on the fridge and check the batteries are charging.

I know firsthand that a campervan is never truly finished: your first trip will be a mixture of excitement, enjoyment and moments of looking over your work and deciding how to improve it. It's in our nature. If you are creative enough to have built your own campervan, that urge will not dissipate. During subsequent trips, gather data on how the various parts of the build function and how you might refine them in the future. The tools will not be packed away for long.

Accept that a well-used campervan needs regular maintenance. Things break and wear out over time. Protect your investment

by performing regular system checks, cleaning the interior and exterior, and keeping the base vehicle in good mechanical order. When the campervan is not in use, try to park it in a level position away from trees. Avoid parking your campervan on grass or close to vegetation as these hold and emit moisture, which is not great for the bodywork or chassis. Consider covering it during the cold months and ideally park it inside a dry space.

Be prepared for how much this vehicle will cement itself into your lifestyle and identity. It will be the catalyst for your adventurous spirit. You will meet fellow campervan owners and travellers on campsites and beaches. You will compare notes and make memories that you will keep close to you for the rest of your life. You have built your own campervan, a home on wheels. Now it's time to enjoy the fruits of your labour. Happy rolling.

Fire extinguiser mounted in an easy to reach position. In the event of a fire inside, it is not hidden in a cupboard, if a fire breaks out outside or in a neighbour's van, anyone can grab it and use it.

SELFBUILD CASE STUDY 04

+ some inspiration

Name: 'Körmi' Kerstin Bürk

Number of campervans converted: 2

Campervan make & model: Piaggio Porter 1,870 mm height, 1,810 mm wheelbase

Converted by: Myself and a friend who is a carpenter

Used for: Month-long trips

Key conversion factors: Budget, versatility of the campervan. Advice: Really just start, and don't overthink it in the beginning. Don't be afraid – even on a budget you can make a cosy home that fits your needs.

The inspiration behind this conversion was that I wanted to have some kind of home for my adventures and wave hunt. I chose this small one because I wanted it to still fit anywhere and not be recognised as a big campervan.

The campervan layout is a bit like a Swiss army knife: there's a big sideboard with all the multifunctions and storage space, and then there's a bed that can be transformed into a sitting area. Under the tailgate you can pull out a relatively big kitchen and arrange a nice communal space to sit.

Habitation Systems

This was my first campervan conversion, so I wanted to take a simple approach. When it came to the habitation systems, for many years I didn't have any power in my van. I just used the cigarette lighter to charge my phone. Now I have a little power station with foldable solar panel by Dometic. For water, I have a 10l canister for the kitchen, and a 12l self-build outdoor shower with a drainpipe. There's no heating! Just Jimmy, my dog.

Sleep & Rest

There's a fixed bed, which has multiple functions: it can be transformed into a sitting area, and parts can be used in the kitchen and as a bigger table and bar. The back of the bed can be folded into different heights, for chilling, working, sleeping, etc.

Eat

When the weather is bad, there's a cosy space for two to eat inside the van. But when the weather is good, there's space for three to four people to eat outside underneath the tailgate.

Wash

It doesn't have a toilet, but there is an outside shower and sink without a grey water tank.

Play

There's also space for a lot of fun! There are usually two or three surfboards on the roof and one short one inside. Under the bed there's a big storage space organised using several

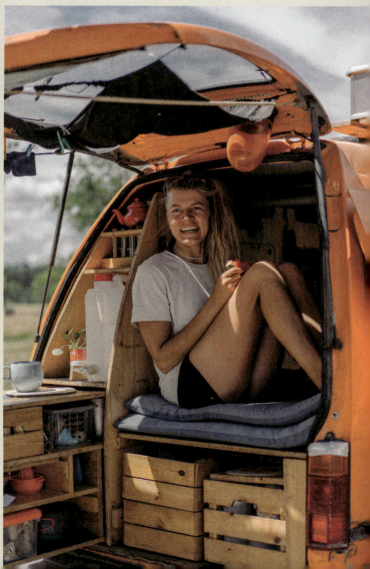

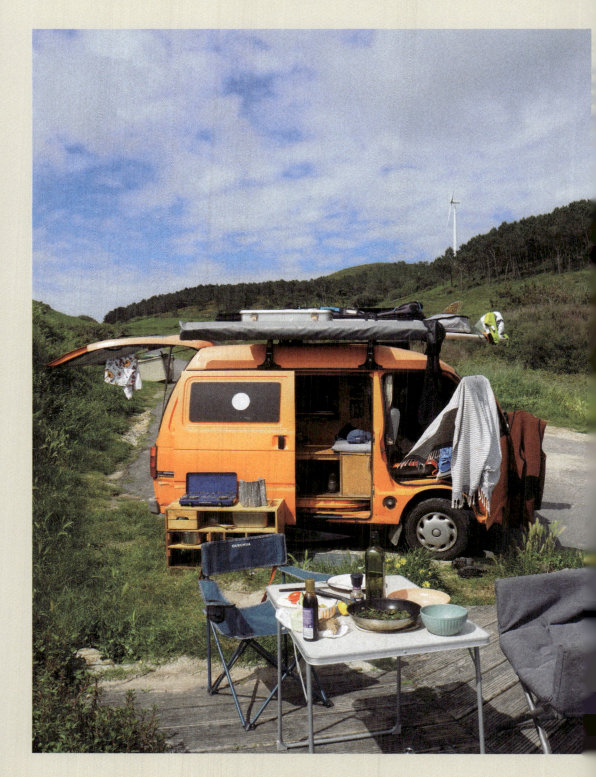

wooden IKEA boxes. On top of the storage space, when the bed is folded up, there's a preparation area. Sometimes I also travel with two sewing machines and my jewellery workshop as well.

Likes
I'm still so happy to have a tiny van that gives me so much freedom and with all the multifunctions – it really works as a home on the go. I love the kitchen, because it's so spacious and inviting, meaning I can connect with others while cooking, eating together or working at the table at the back. I like being forced to be outside most of the time.

Dislikes
I really don't like all the rust. I need to take care of this! Morocco is calling. I already improved the other things, like better organisation of the storage, etc.

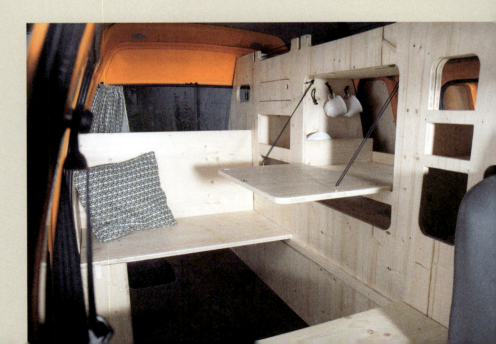

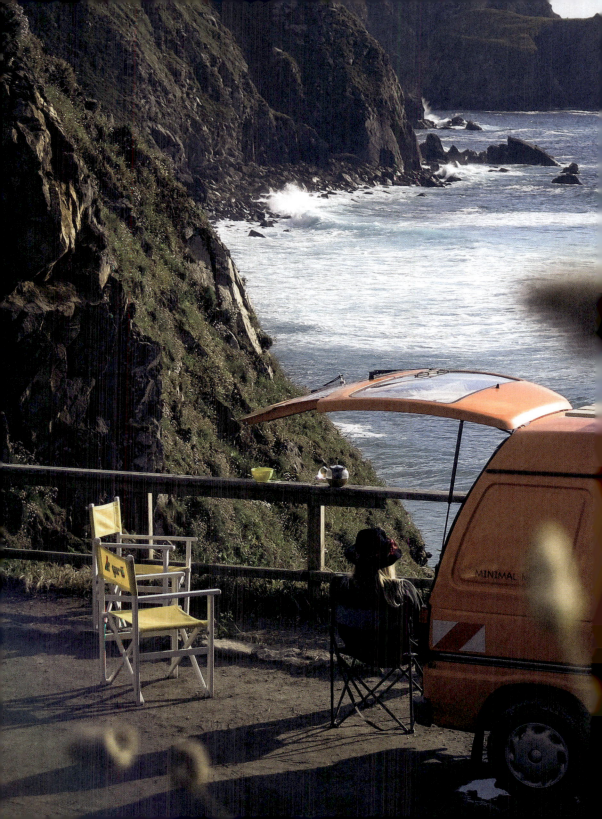

Texts, image selection & book design
Calum Creasey

Copy-editing
Heather Sills

Photography
Calum Creasey
James Bowden (p110)
Andrew & Emma Groves (p139, p140, p143)
Sam Glazebrook (p8, p20-21, p33, p84, p88, p103, p112, p239, p241)
Tom Guilmard (p205, p207)
Marie Bühler (p247, p251)
Marcus Glahn (p249)
'Körmi' Kerstin Bürk (p250, p252-253)

Illustration
Berat Pekmezci (p2)
Vicki Turner (inside covers, p56, p58, p61, p69, p71)

Cover image
Calum Creasey

Back cover images
Calum Creasey

If you have any questions or comments about the material in this book, please do not hesitate to contact our editorial team: art@lannoo.com

© Lannoo Publishers, Tielt, Belgium, 2025
ISBN: 9789401446686
D/2025/45/9 - Thema: TR, WT, WF
www.lannoo.com

All rights reserved. No part of this publication may be reproduced or transmitted in any form or by any means, electronic or mechanical, including photocopy, recording or any other information storage and retrieval system, without prior permission in writing from the publisher.

Every effort has been made to trace copyright holders. If, however, you feel that you have inadvertently been overlooked, please contact the publishers.